Johanna Basford

World of Flowers

A Coloring Book & Floral Adventure

PENGUIN BOOKS
An imprint of Penguin Random House LLC
penguinrandomhouse.com

A Penguin Life Book

ISBN 9780143133827

Printed in China

17

Interior designed by Johanna Basford and Sabrina Bowers

This book belongs to

..

Introduction

This book was inspired by my grandmother, Joan, who was both a gardener and an artist. When she came across a flower she had not found before, she would look it up in one of her botanical reference books, then delicately color the black-and-white illustration printed in the book, being sure to try to exactly match the specimen she had found.

I loved the way her books became a colorful tale of the flowers of her life. We can't all travel the world in search of rare orchids or exotic blooms, but we can still let our imaginations run wild! This book contains hundreds of blooms for you to bring to life. Some real, some imagined, and some an inky mix of the two.

Grab your pens and pencils, start adding color to the pages, and let's go on a petal-packed adventure together!

Johanna x

Tips for Coloring

✿ Pencils are the most versatile medium for coloring. You can blend and layer them to create lots of amazing effects.

✿ Pens are more vibrant but also a little less forgiving. Use them alone for bright pops of color or over coloring pencil to add inky details.

✿ If using pens, try them on the color palette test pages at the back of this book to check if they bleed, try not to press too hard, and don't go over the same area repeatedly.

✿ Always slip a sheet or two of blank paper behind the page you are working on to act as a cushion and prevent indentation or transfer of ink.

✿ For color inspiration, you could visit a garden or a garden center, look at photographs on Pinterest, or just use your imagination and make it up as you go along. (The latter is always my preferred option!)

✿ Share your creations with the world! Show friends, upload to my Coloring Gallery, or post pictures online with #worldofflowers.

✿ For more coloring tips and lots of tutorials, visit www.johannabasford.com.

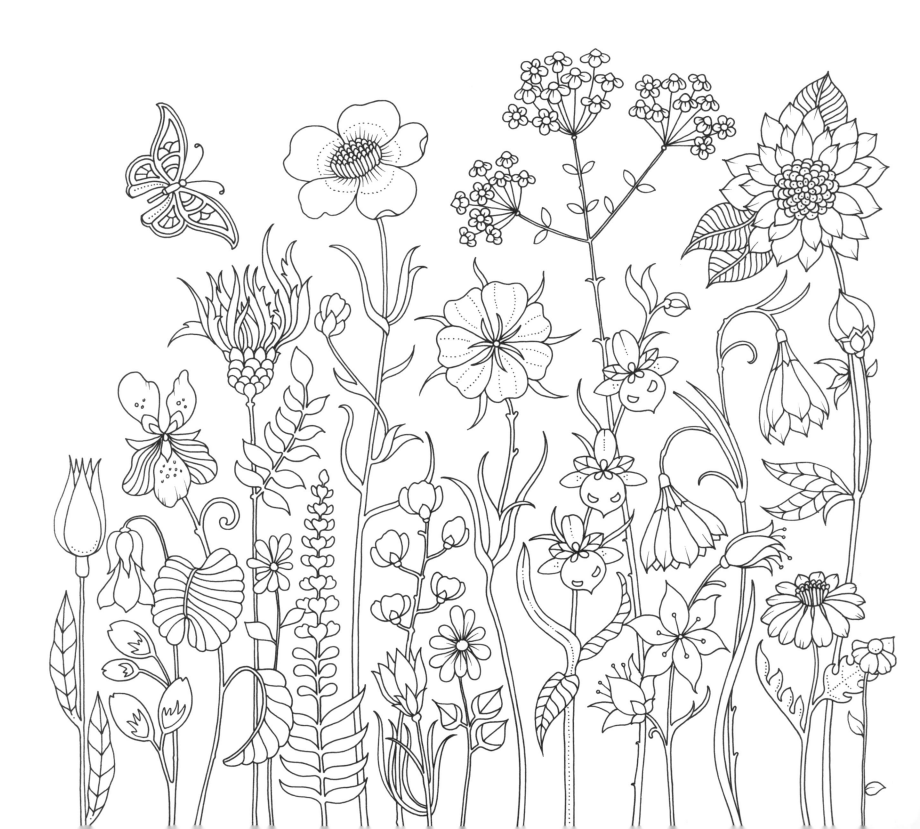

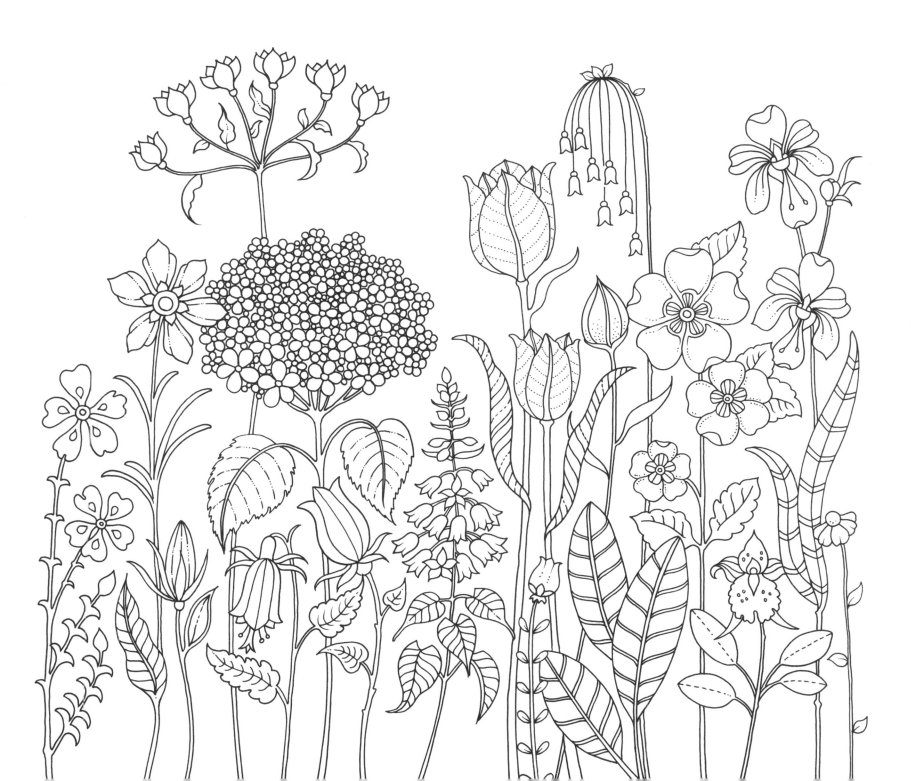

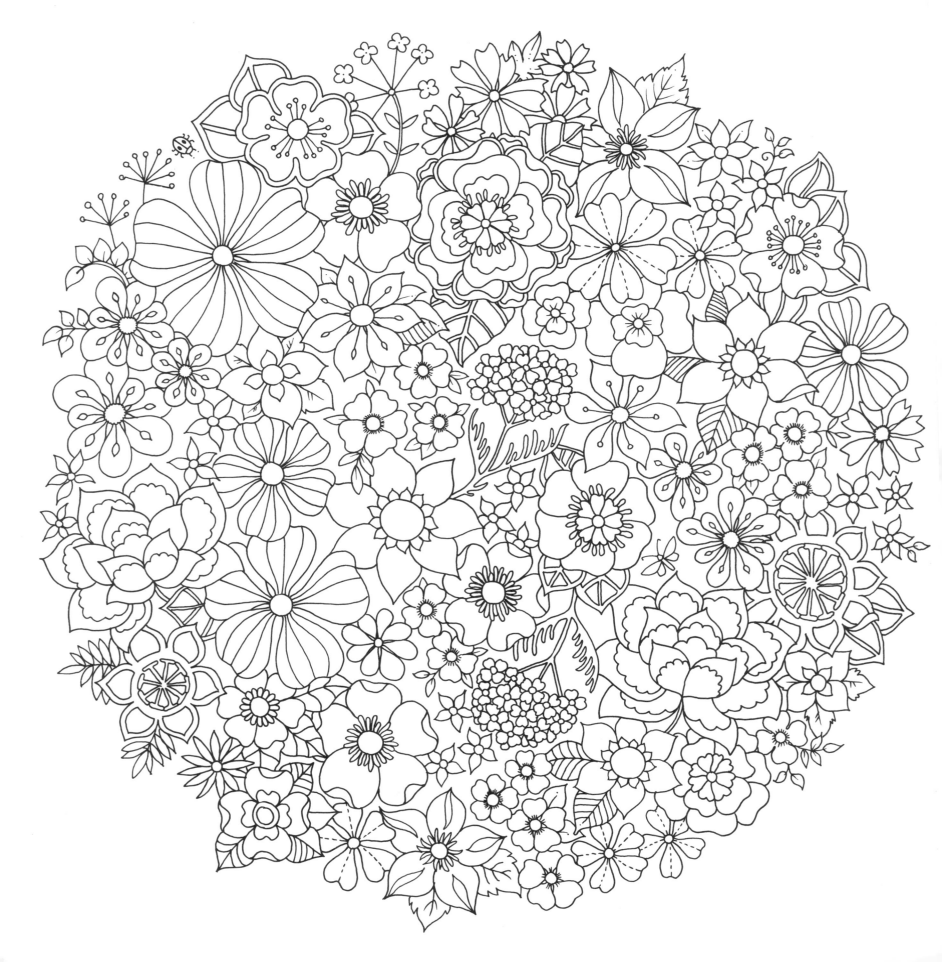

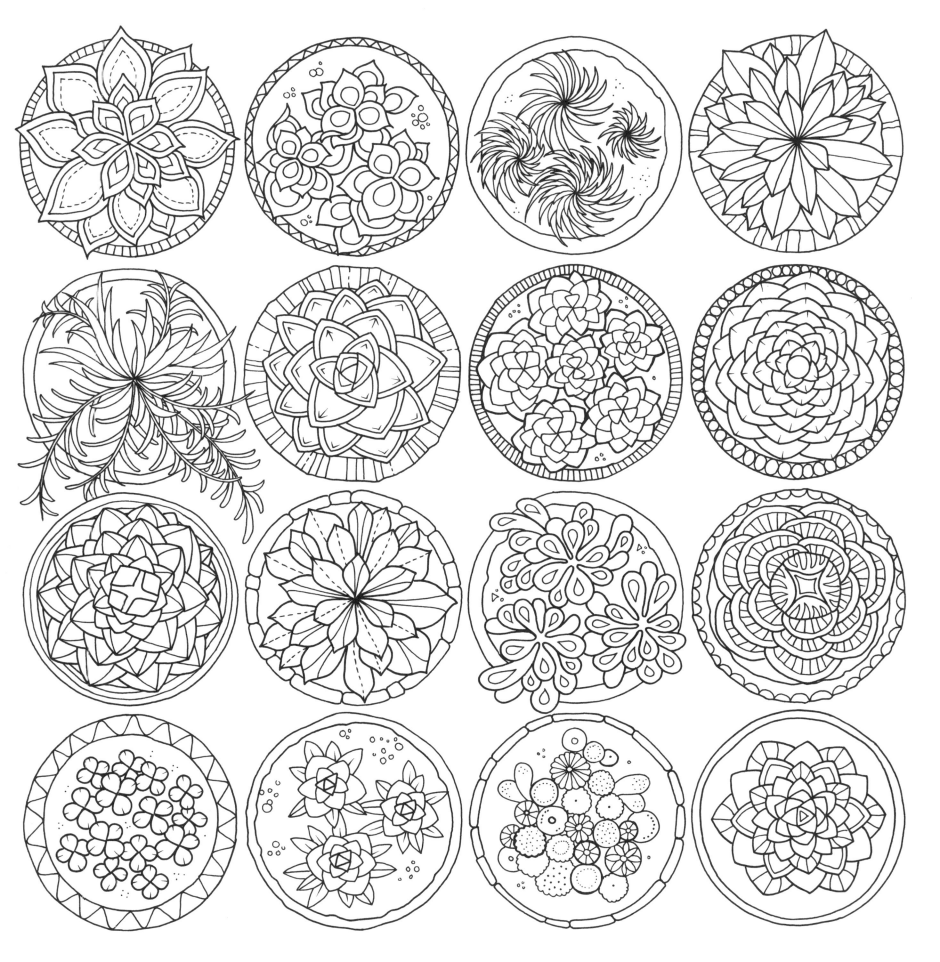

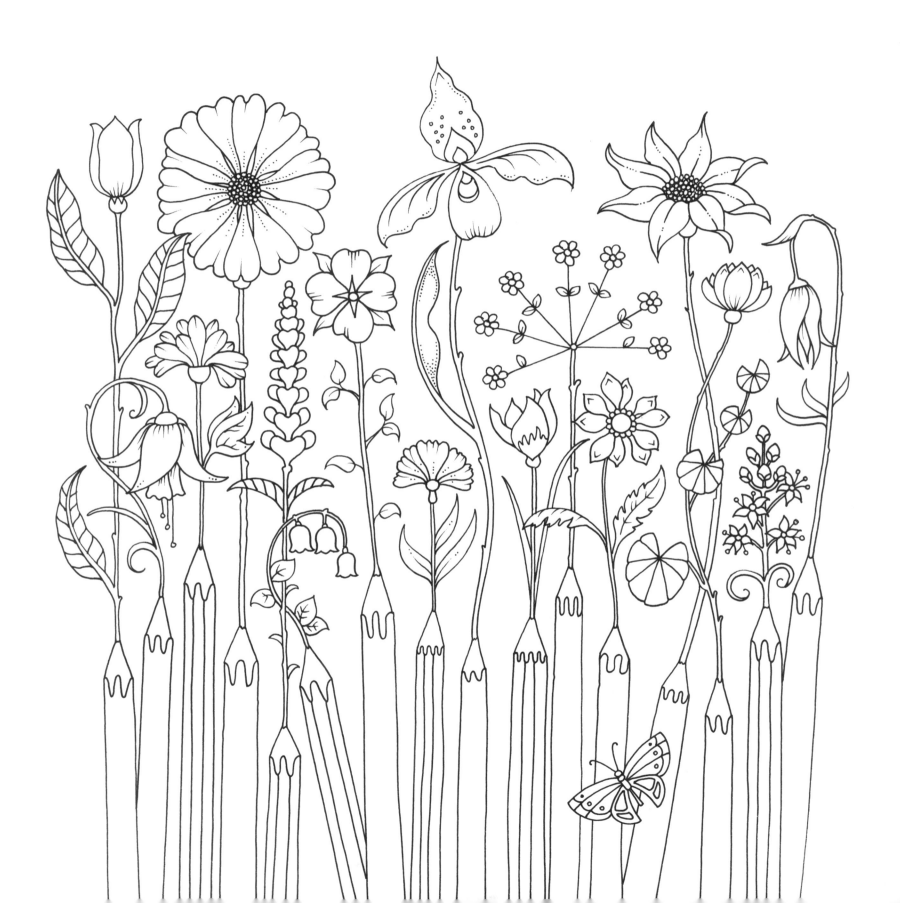

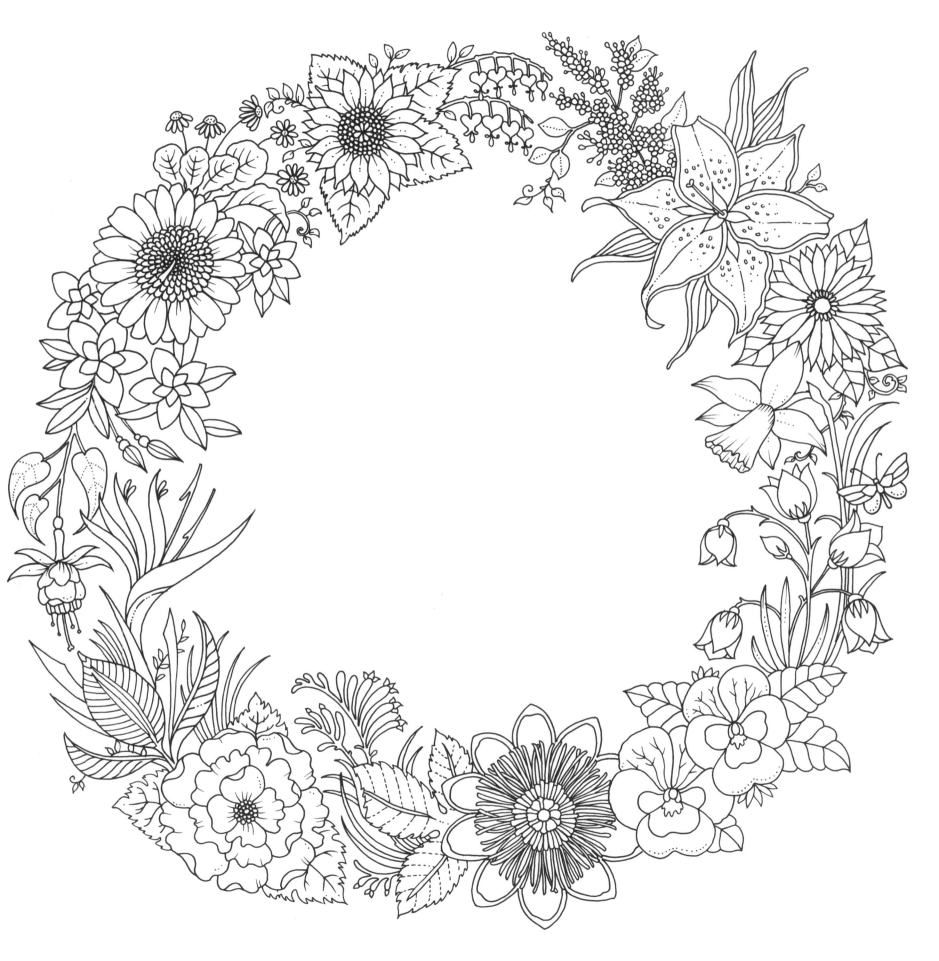

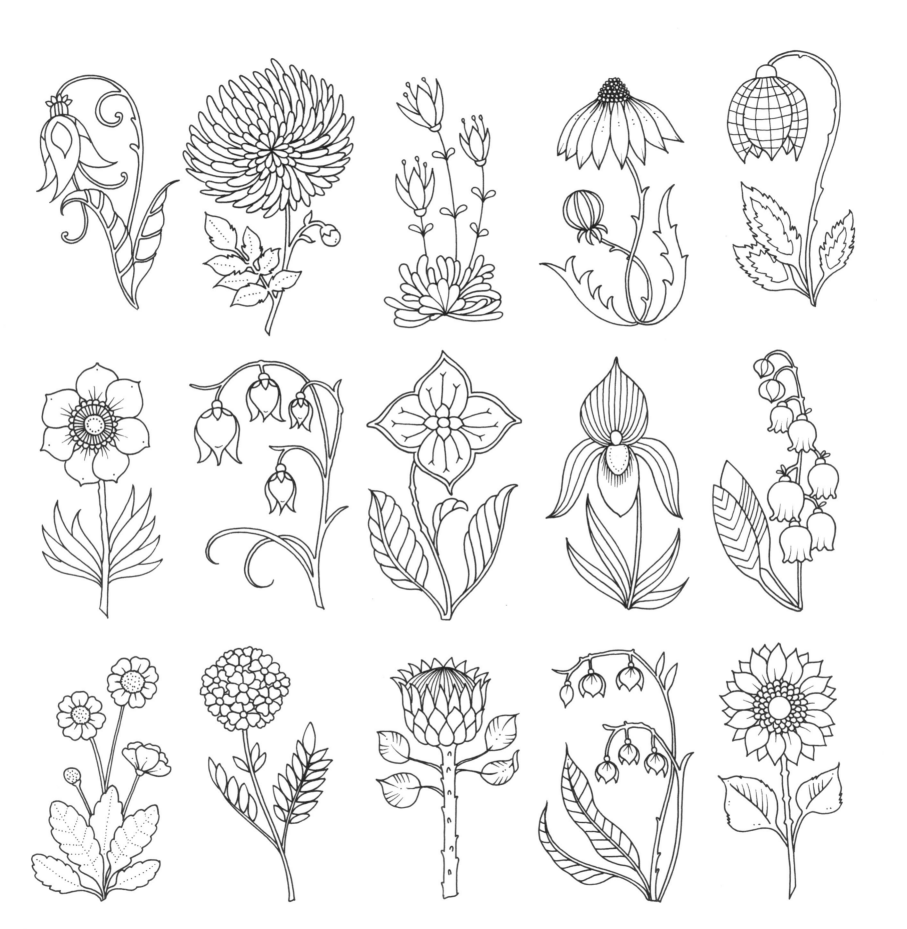

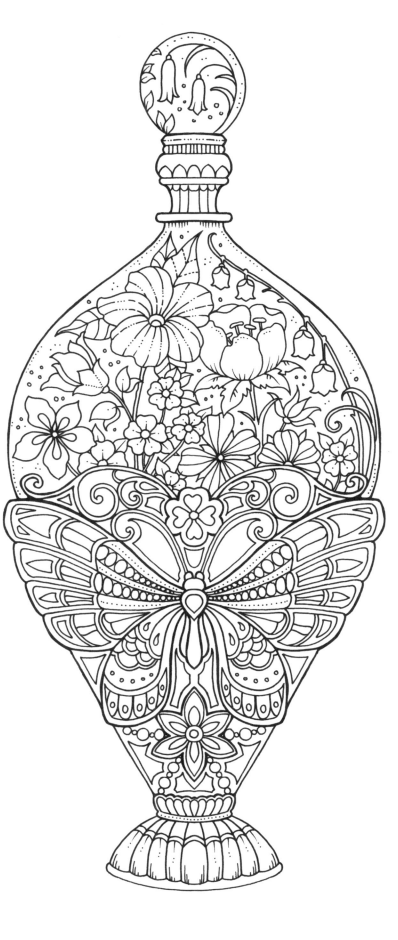

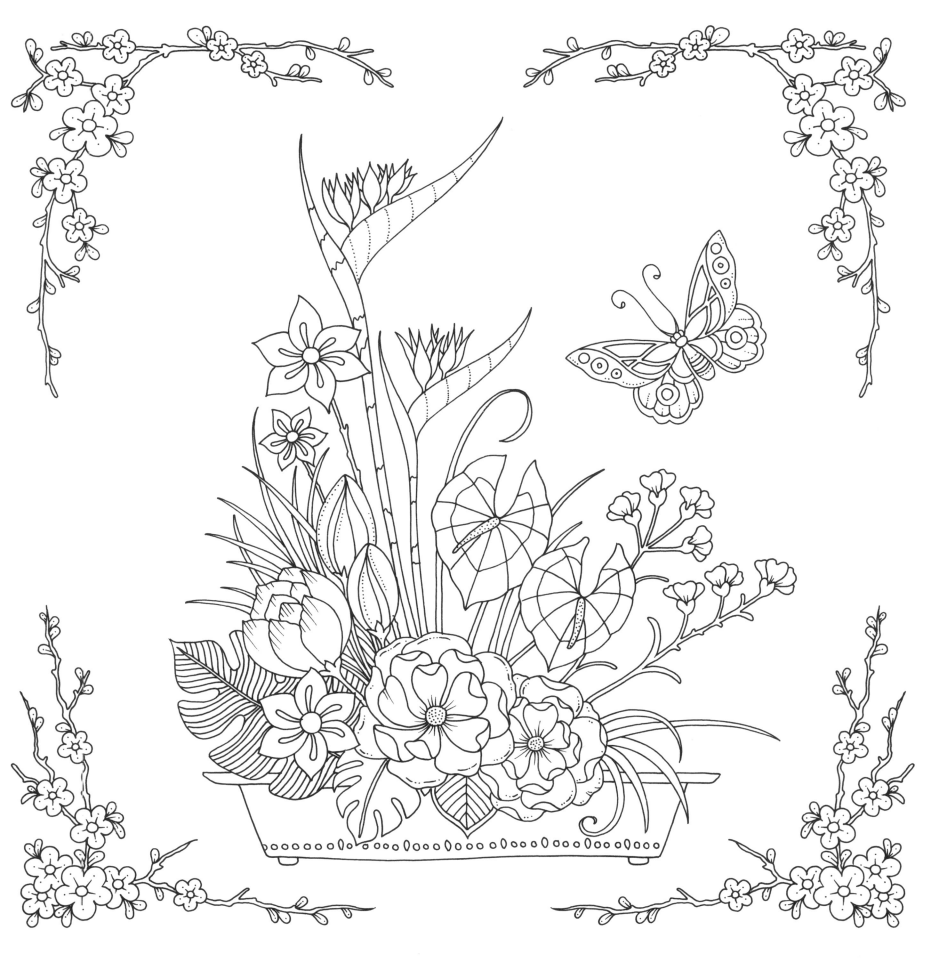

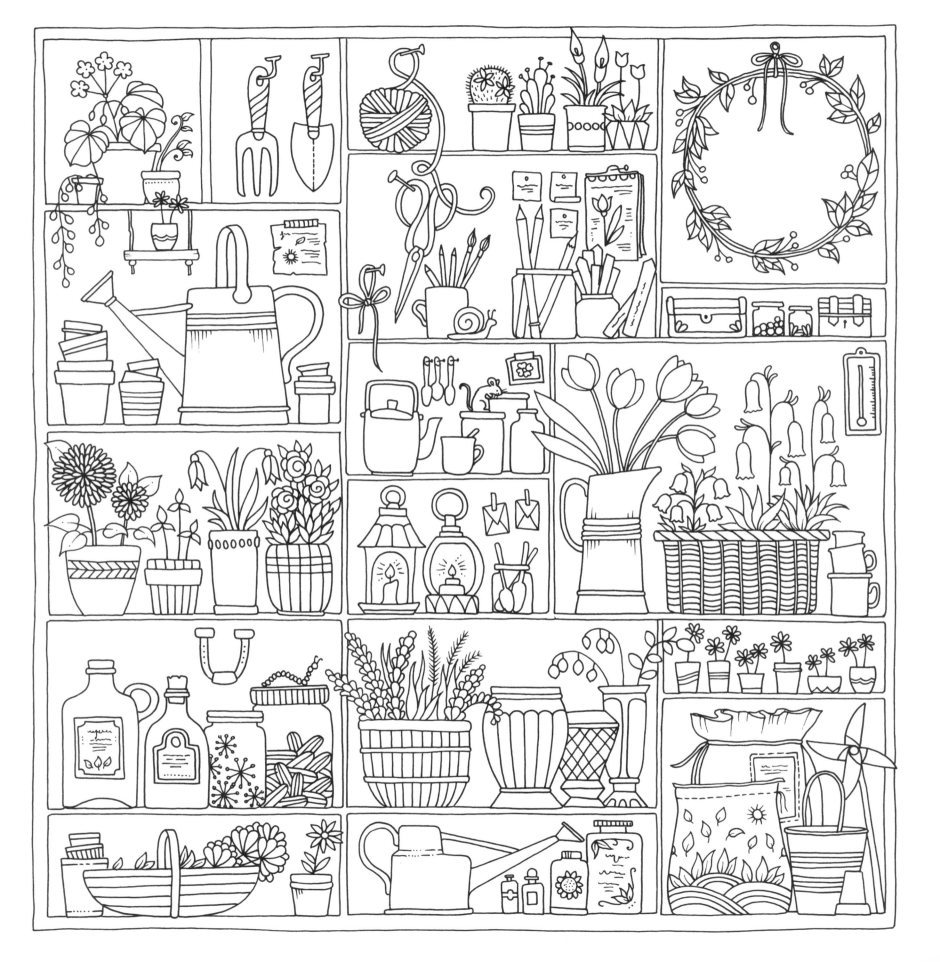

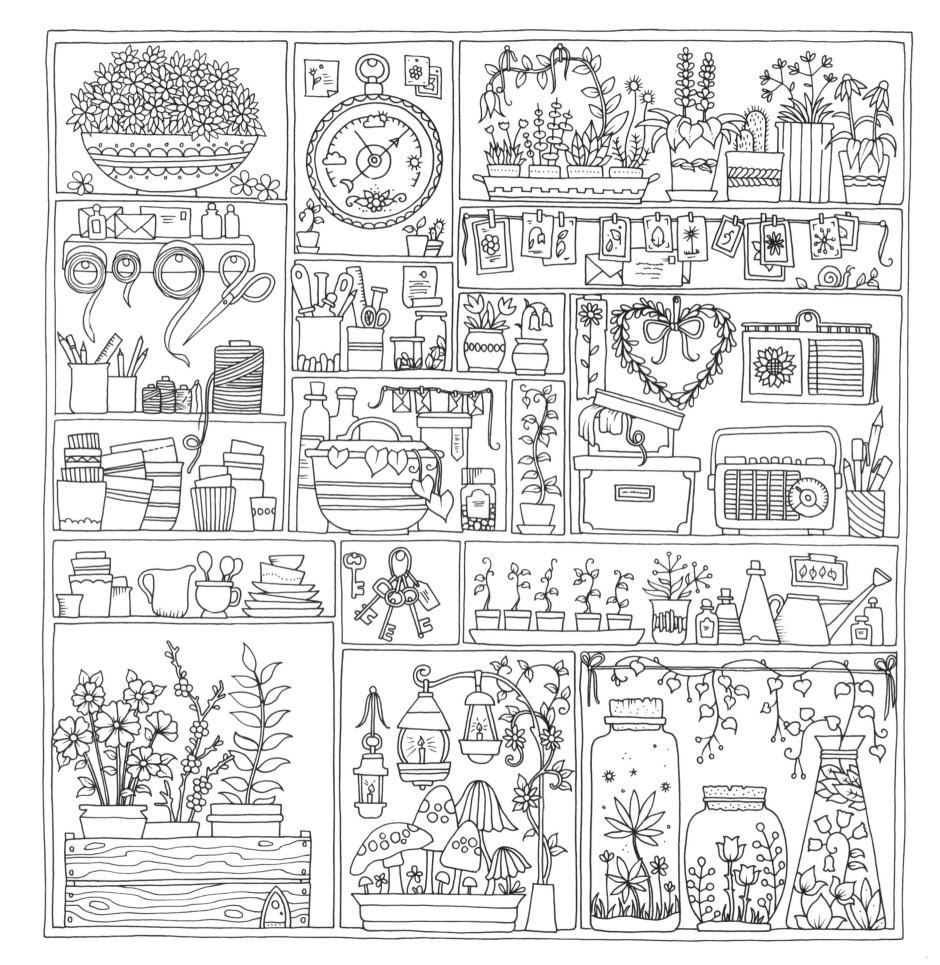

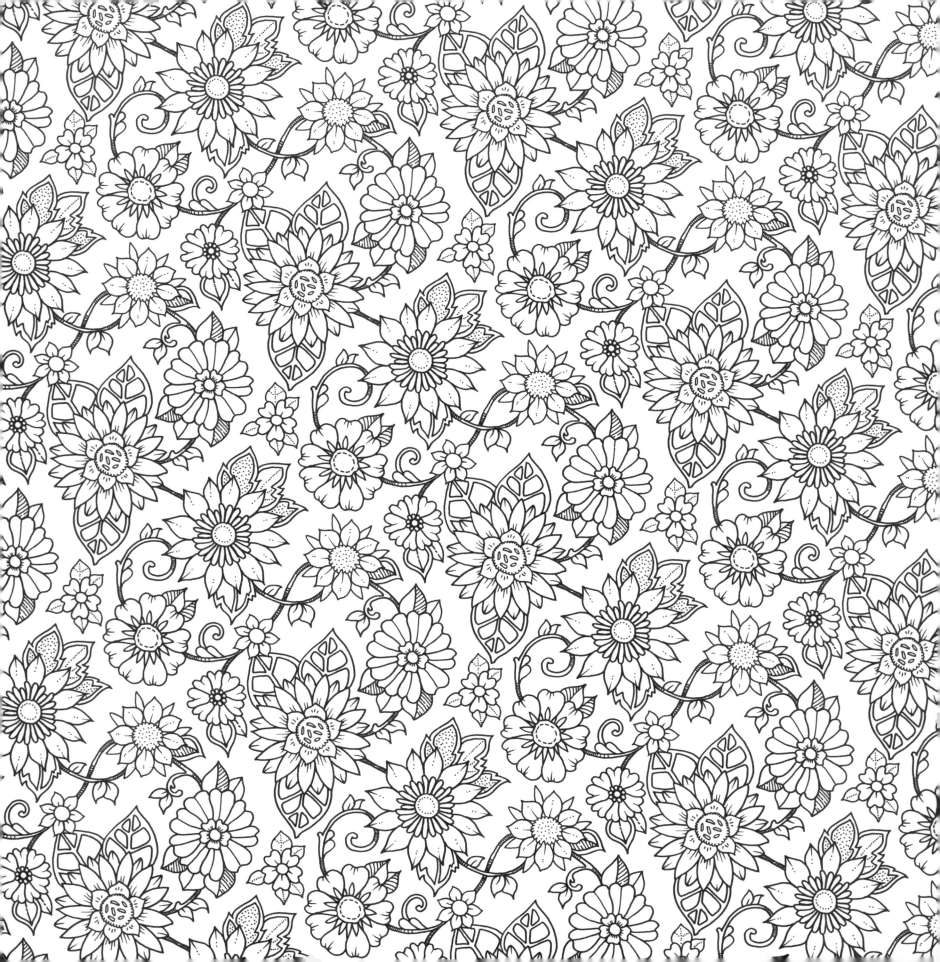

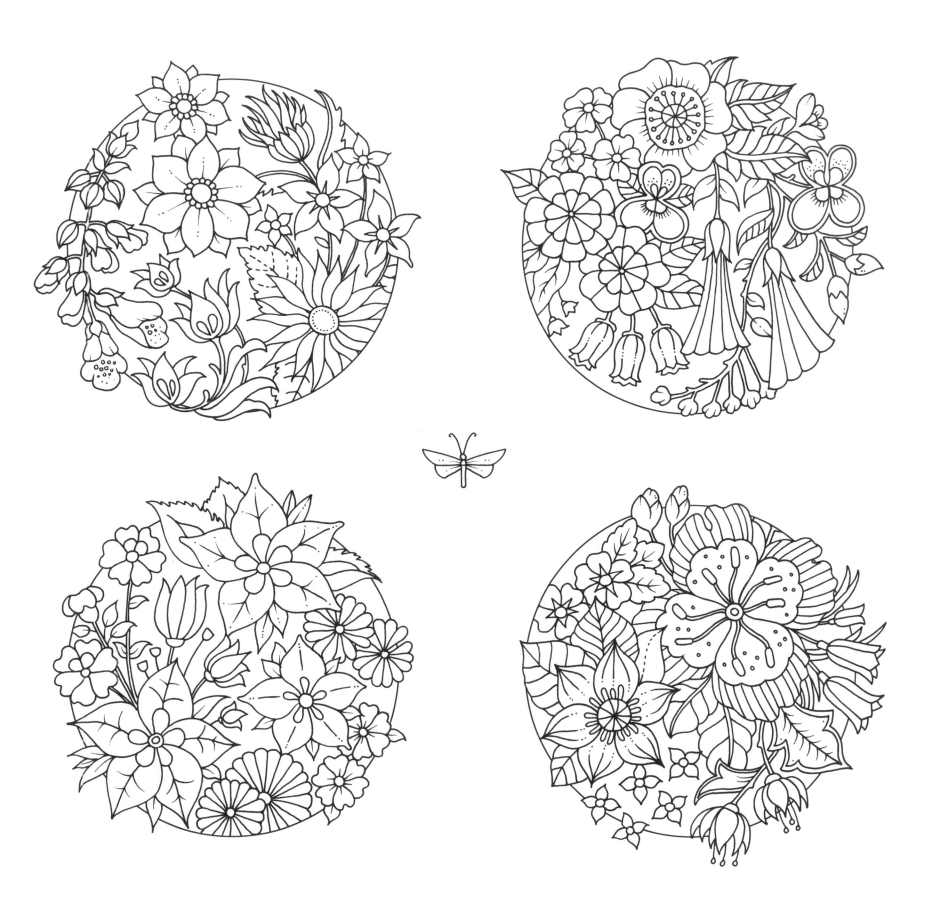

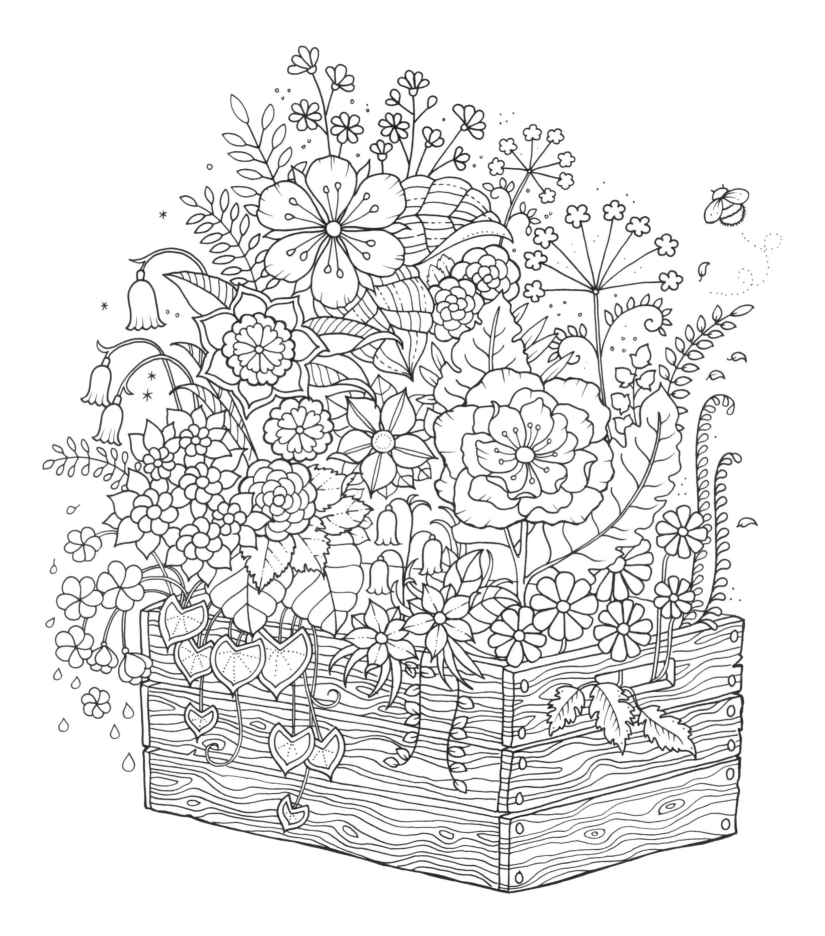

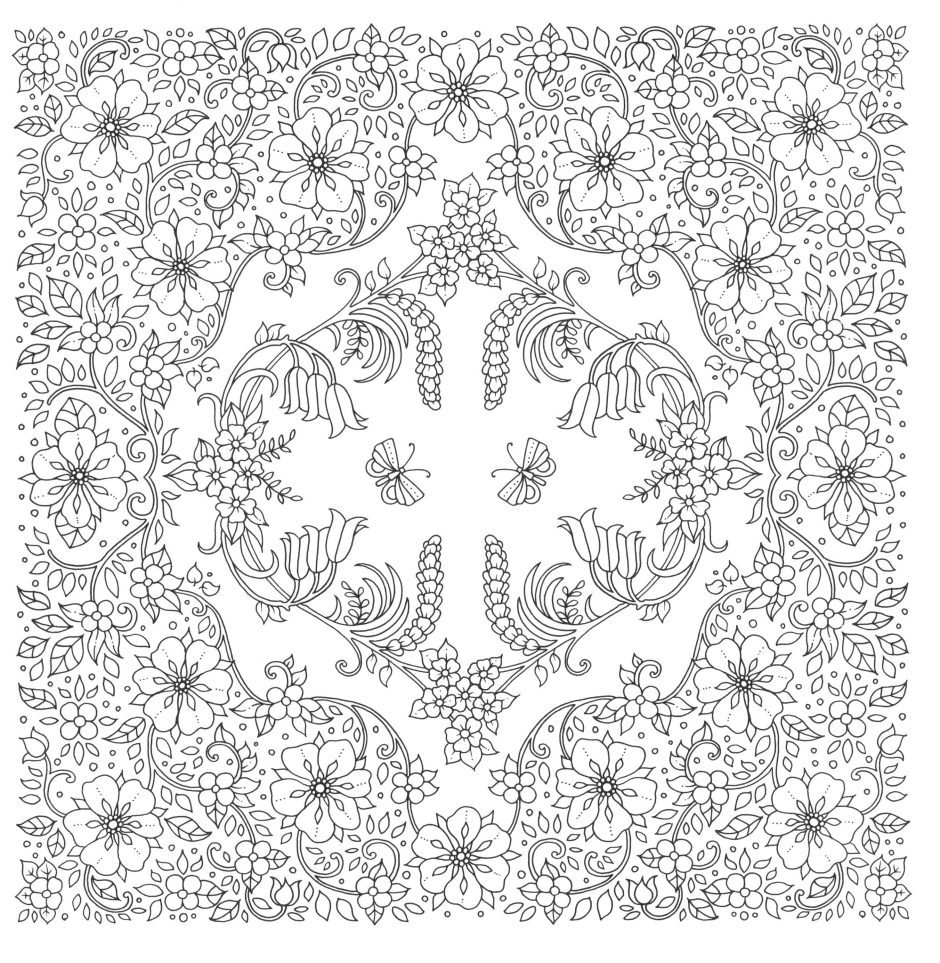

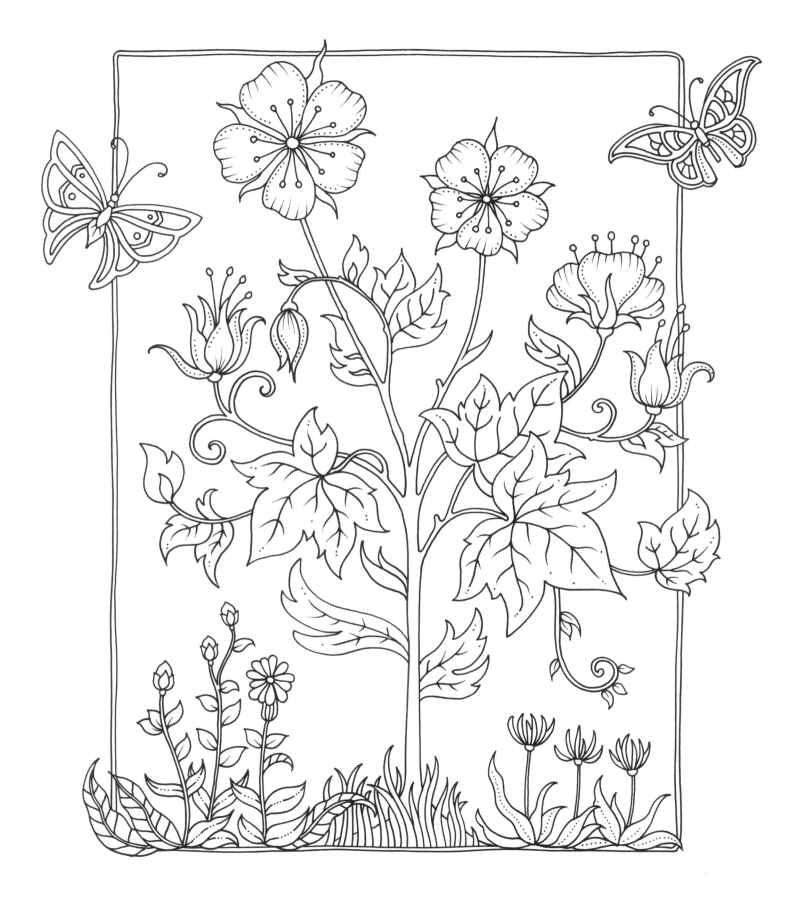

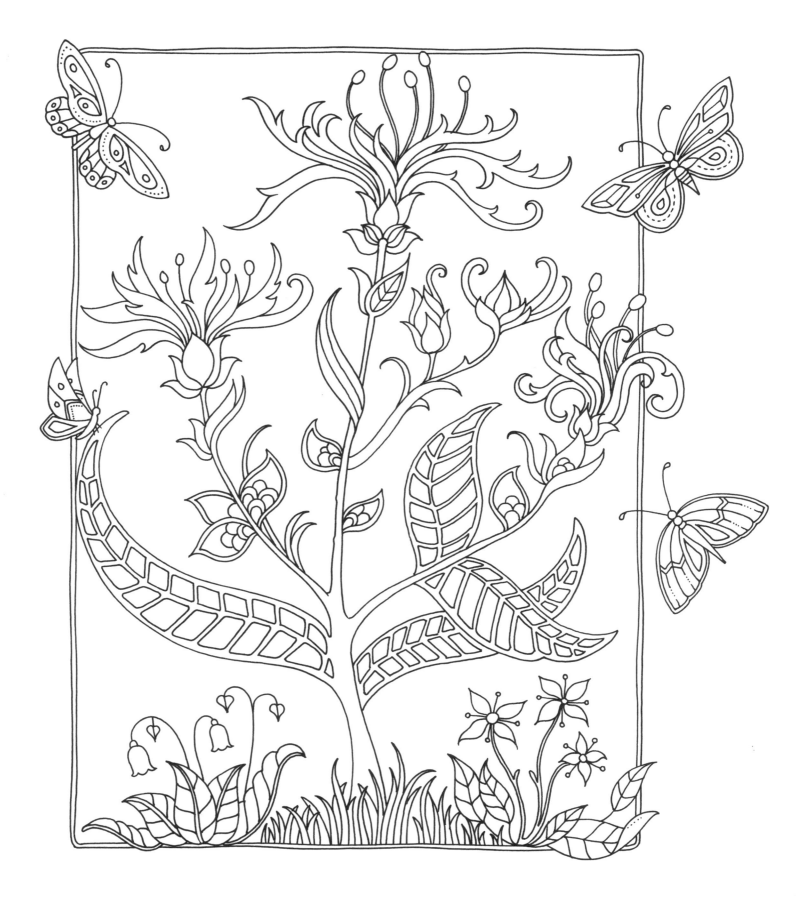

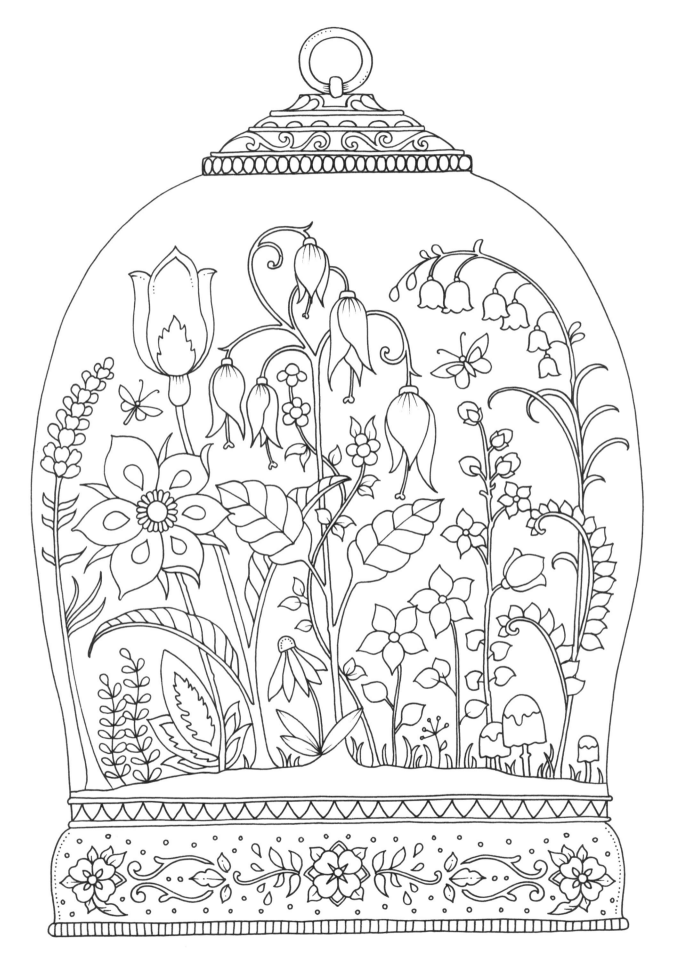

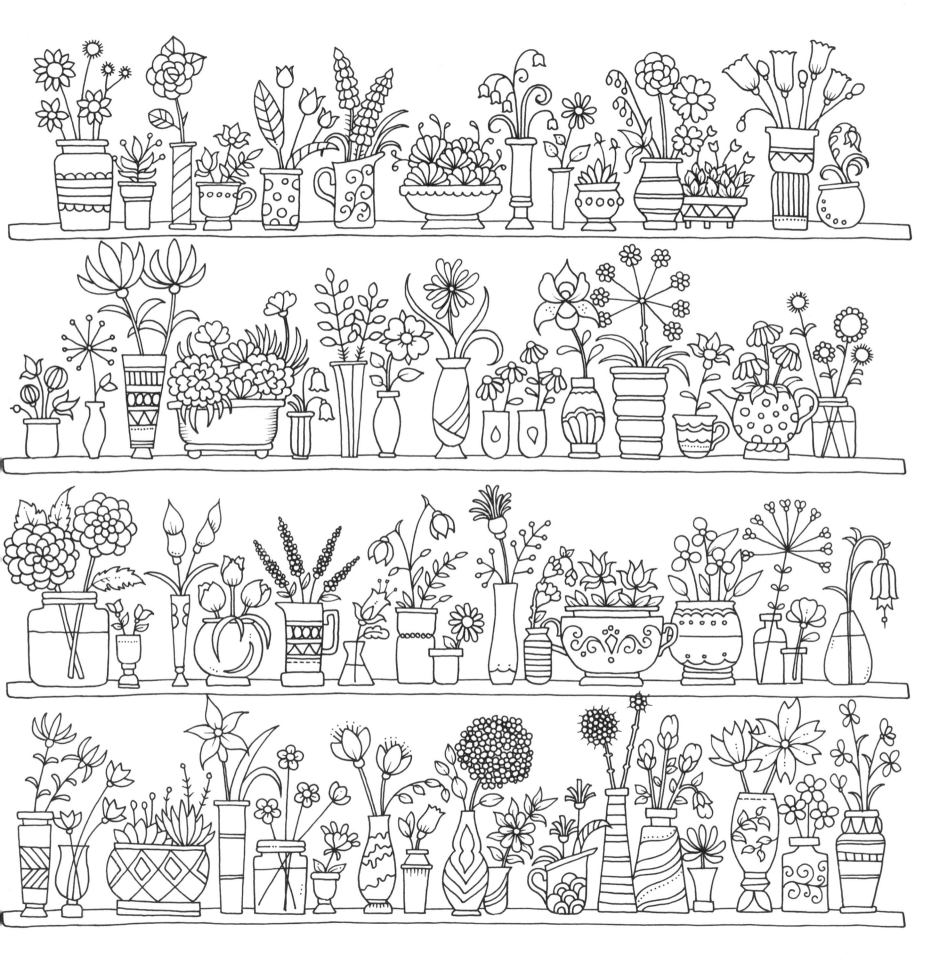

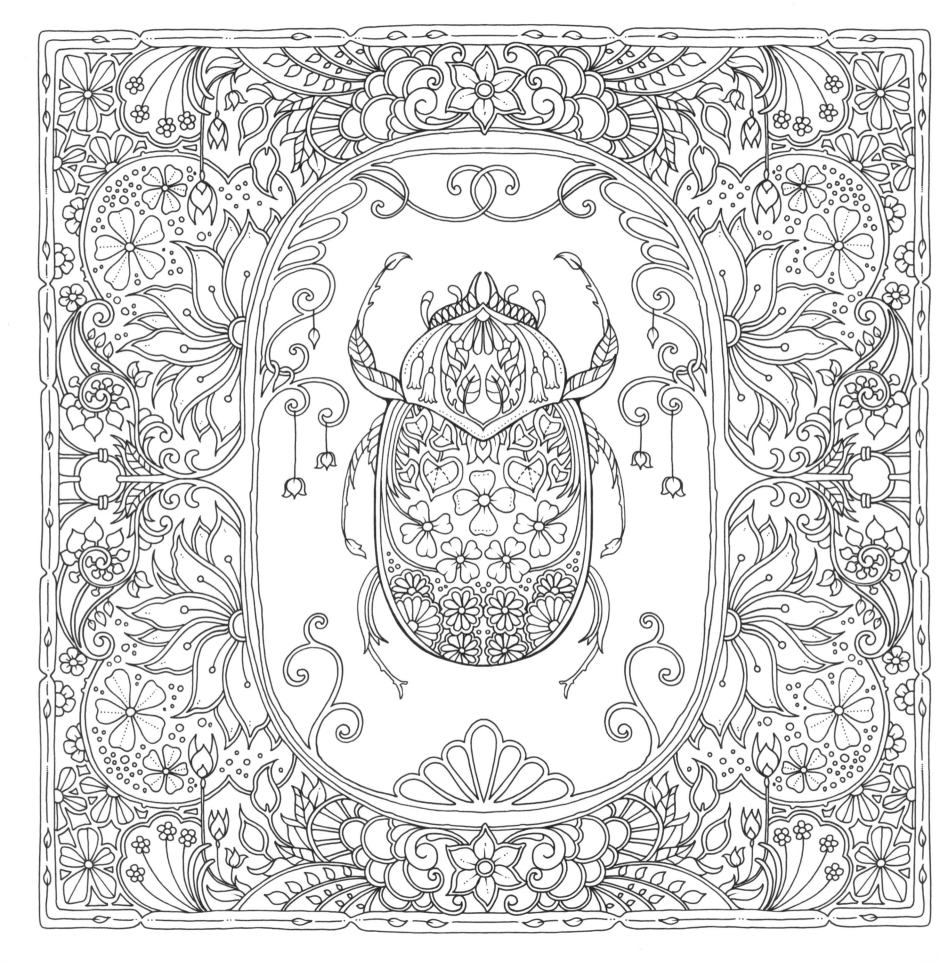

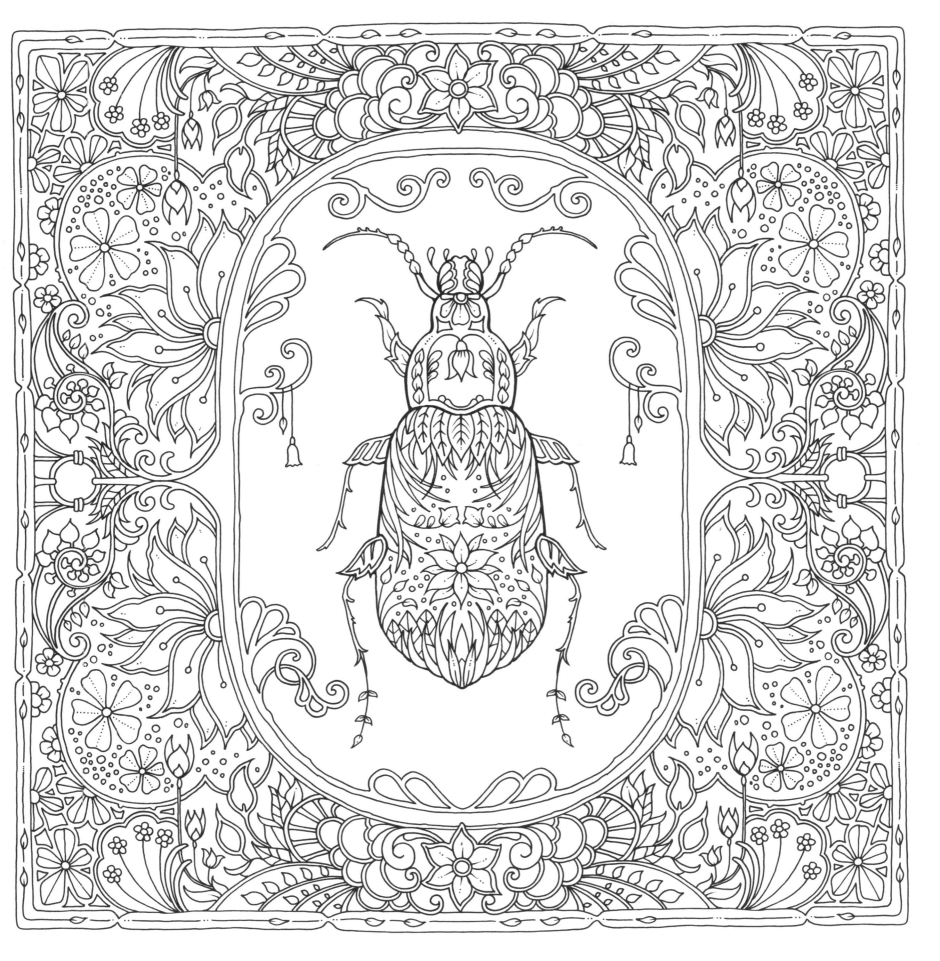

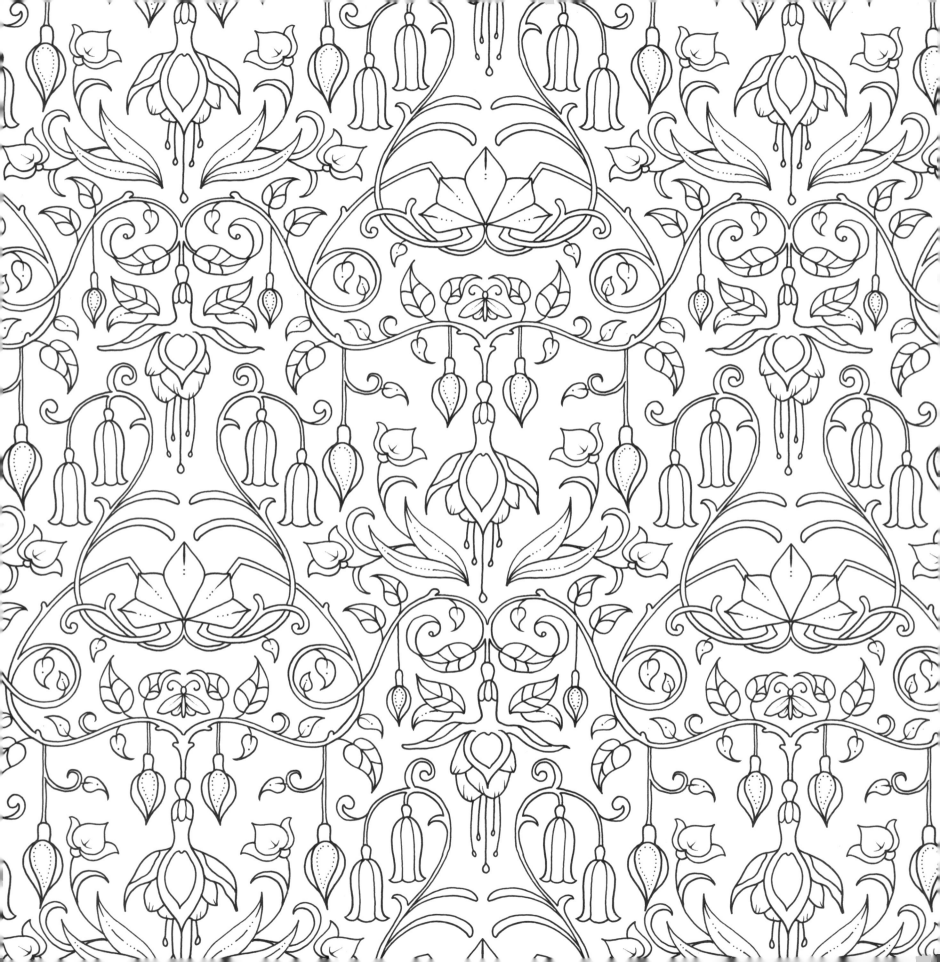

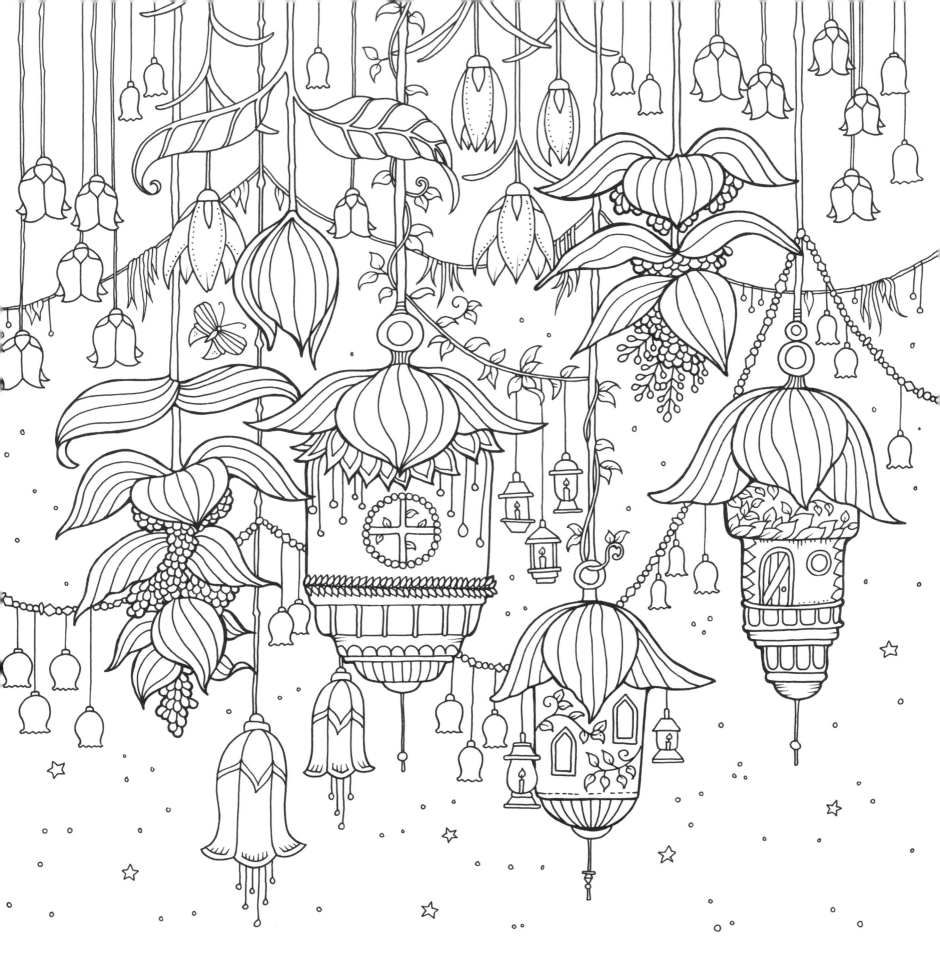

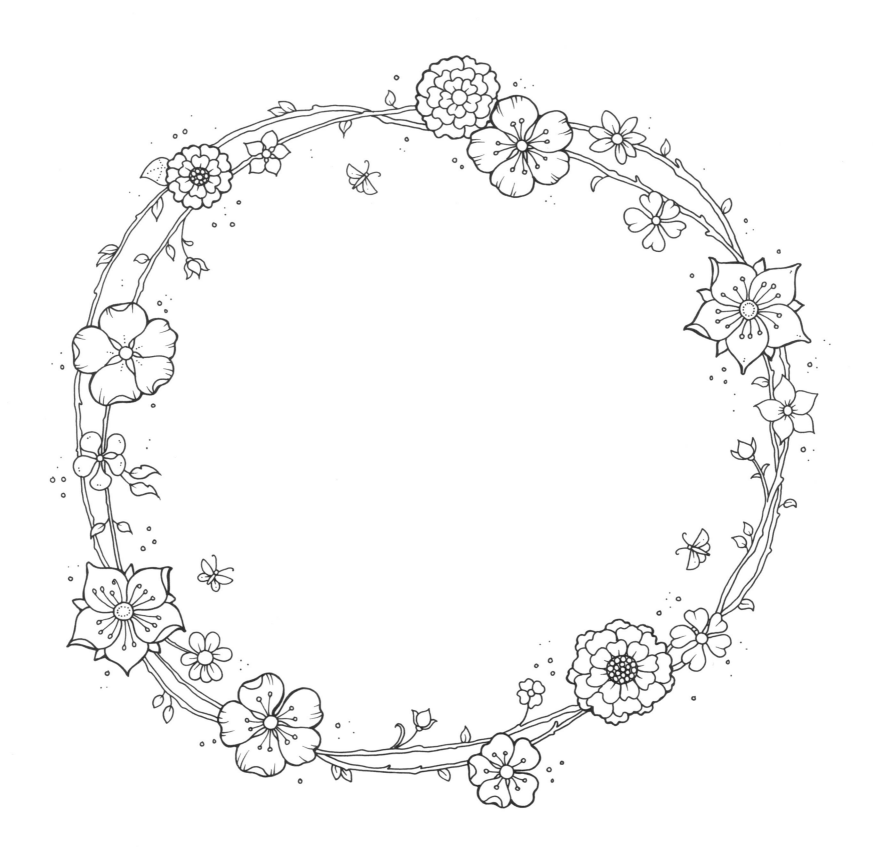

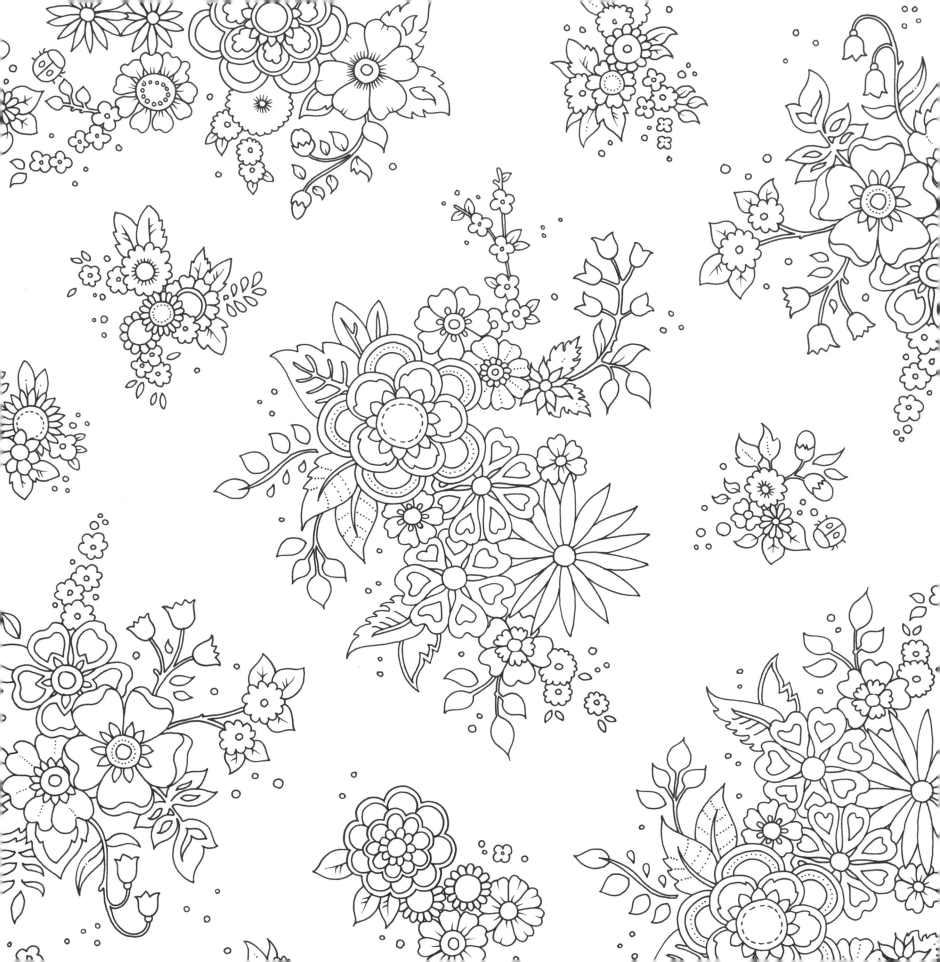

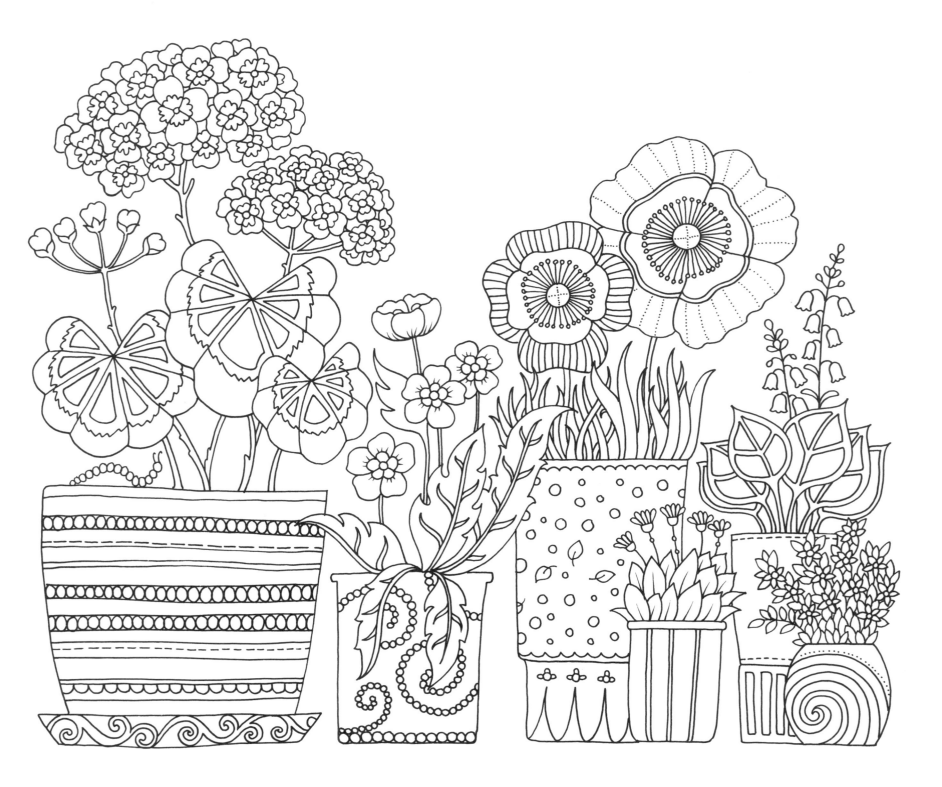

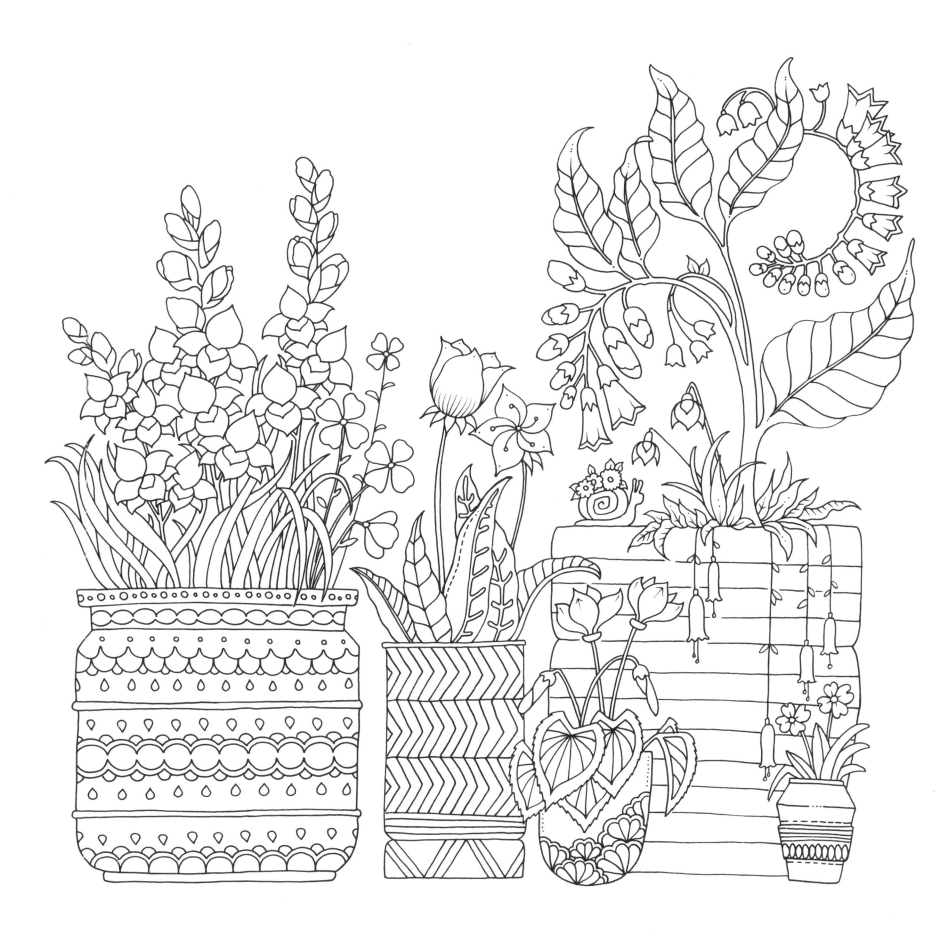

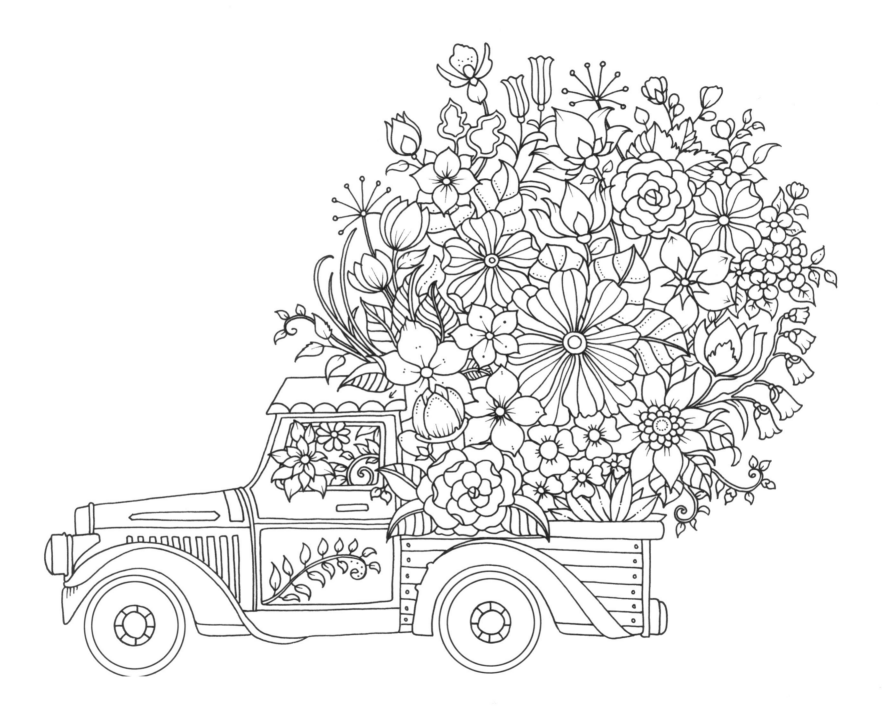

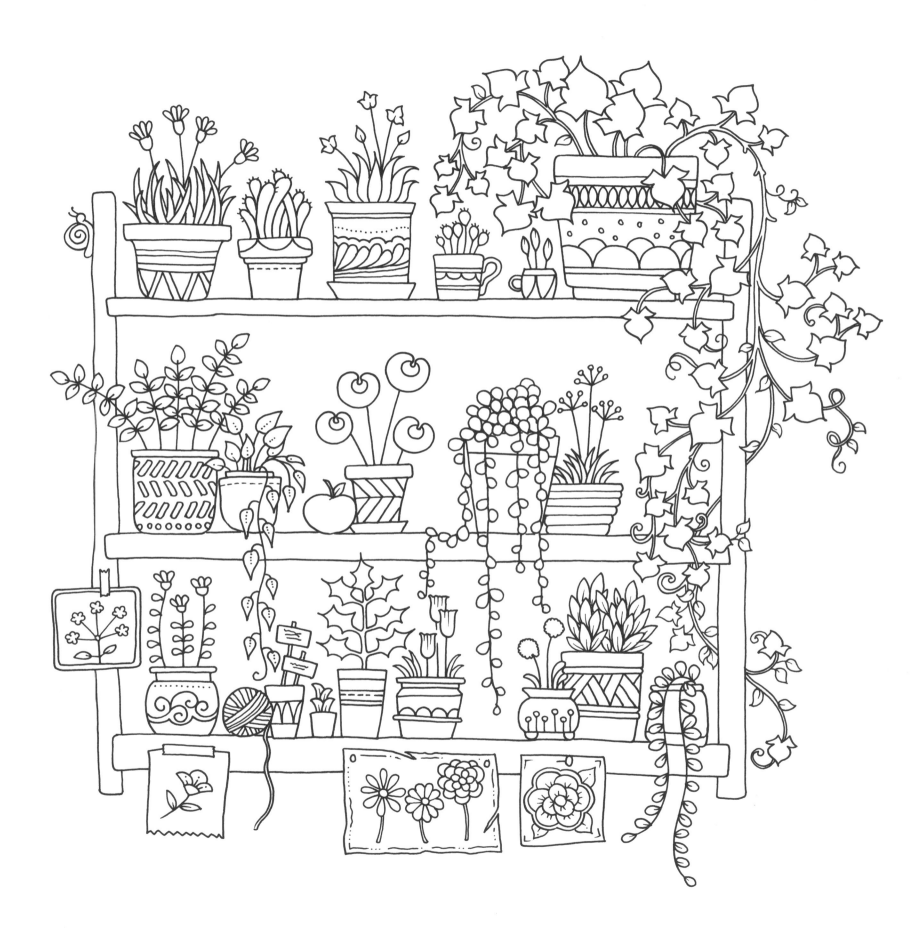

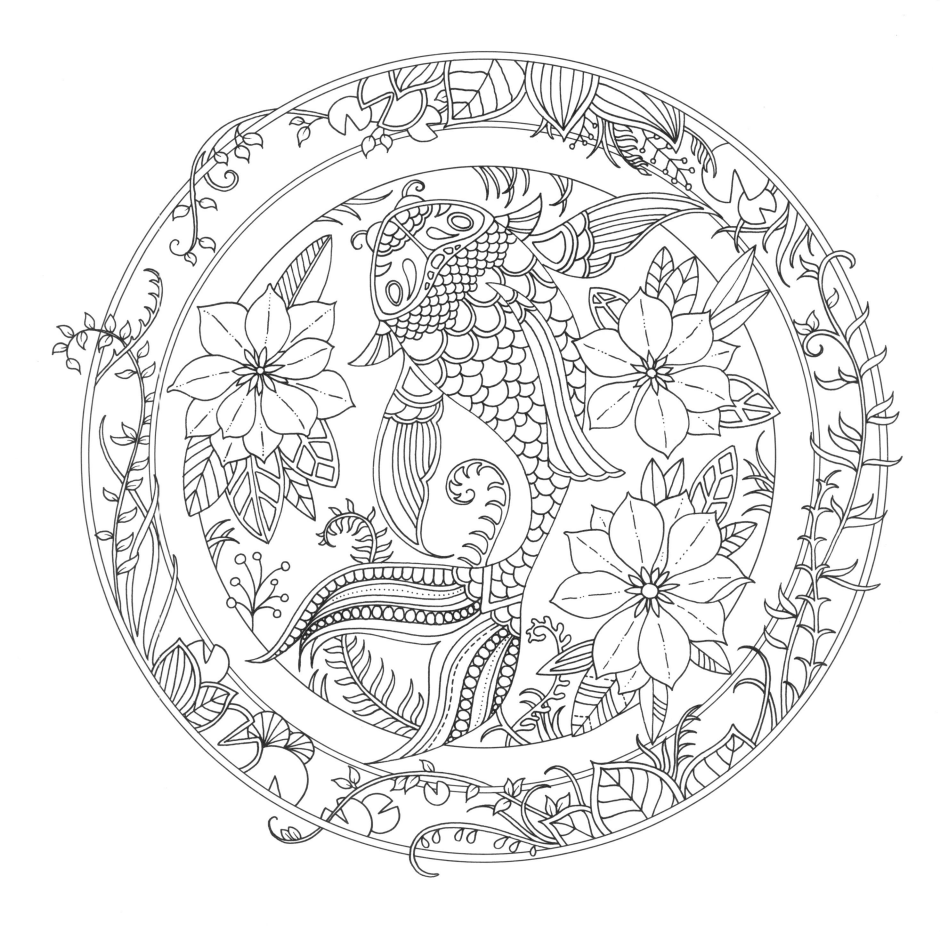

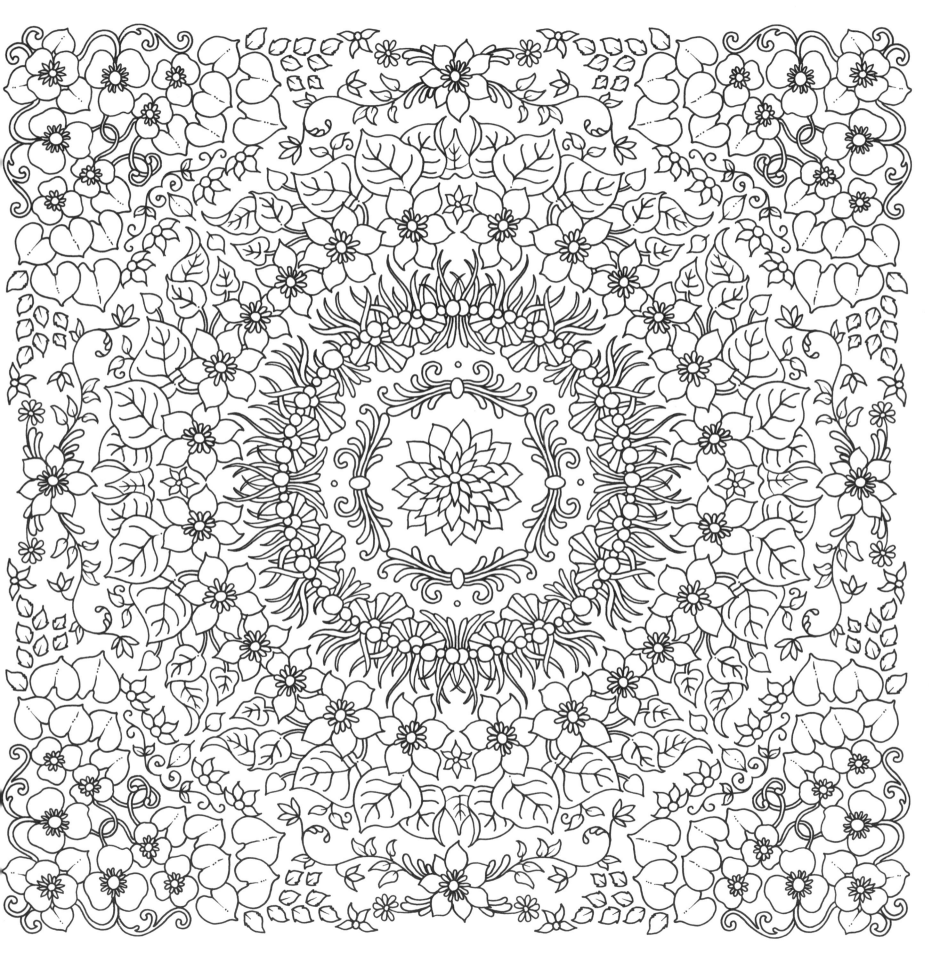

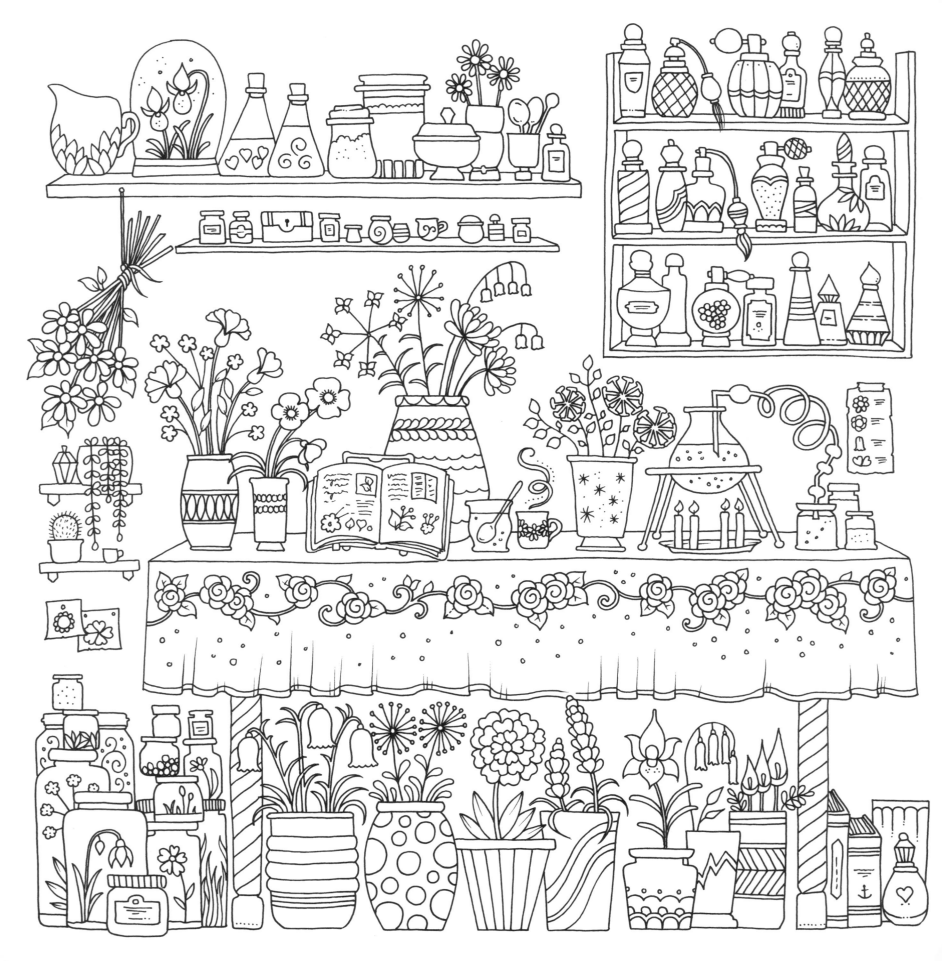

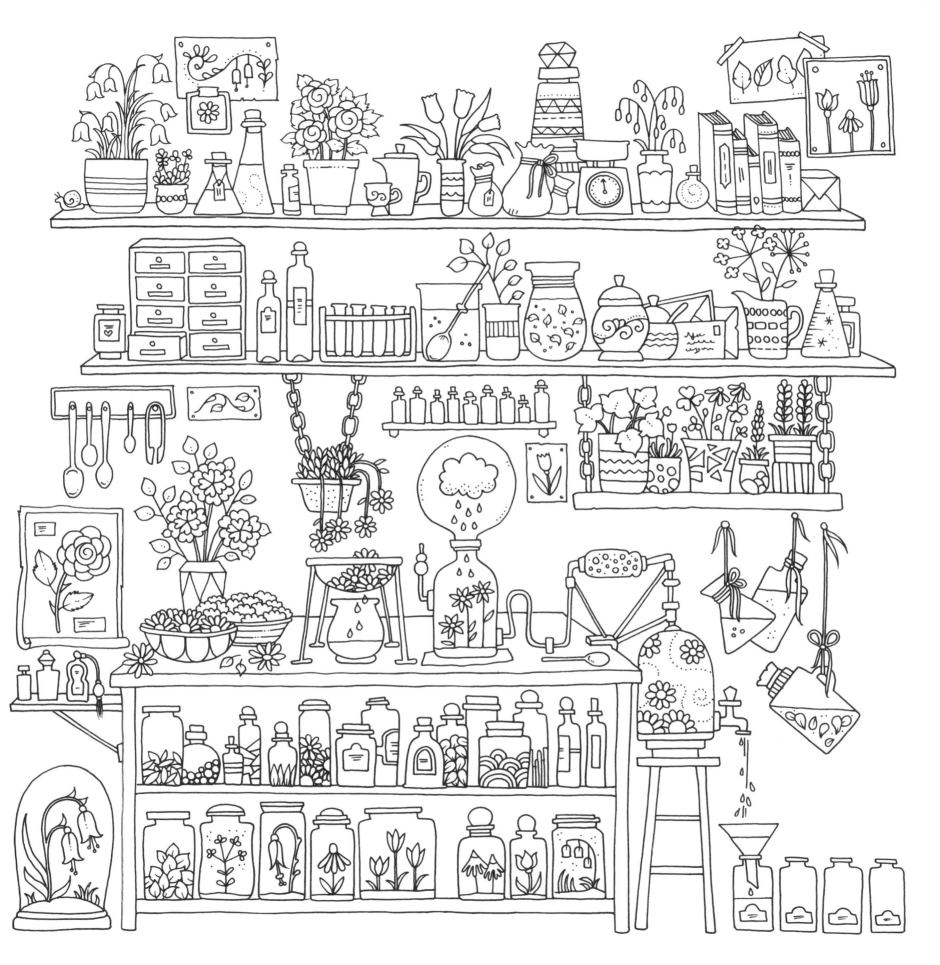

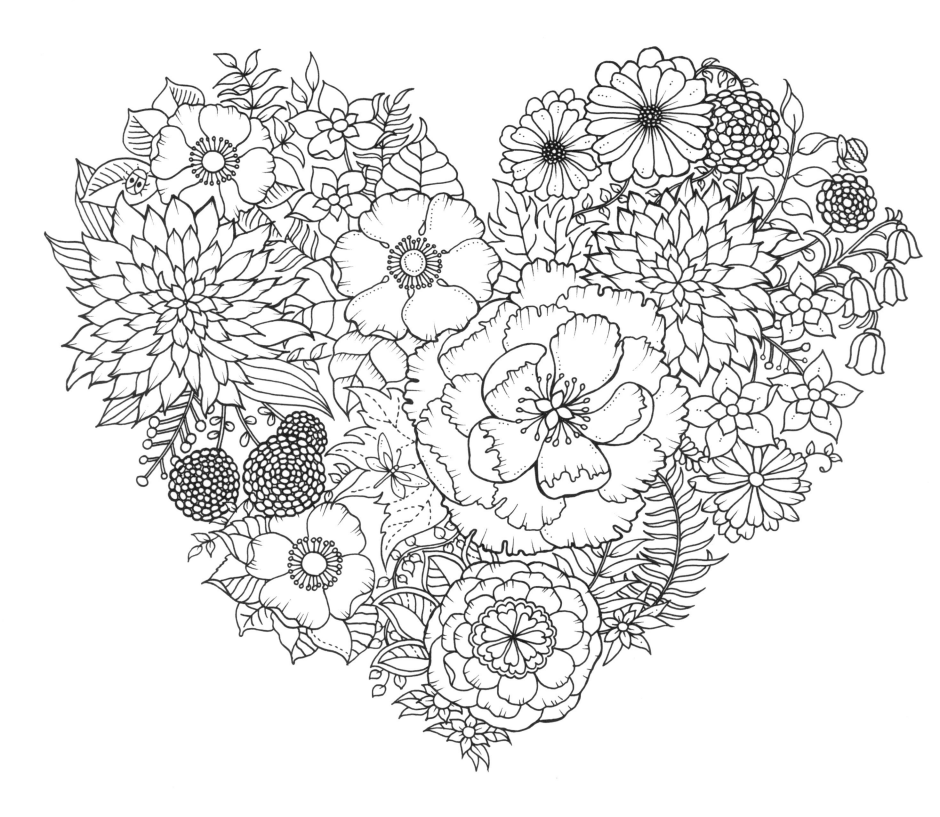

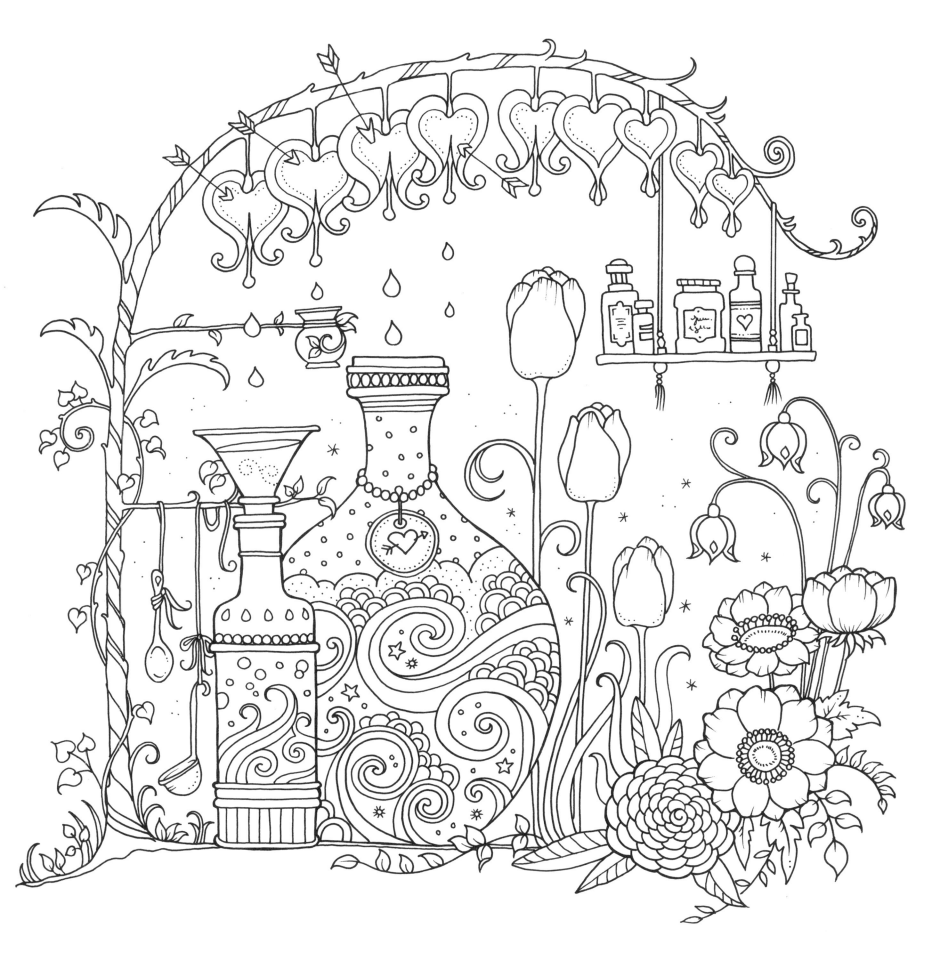

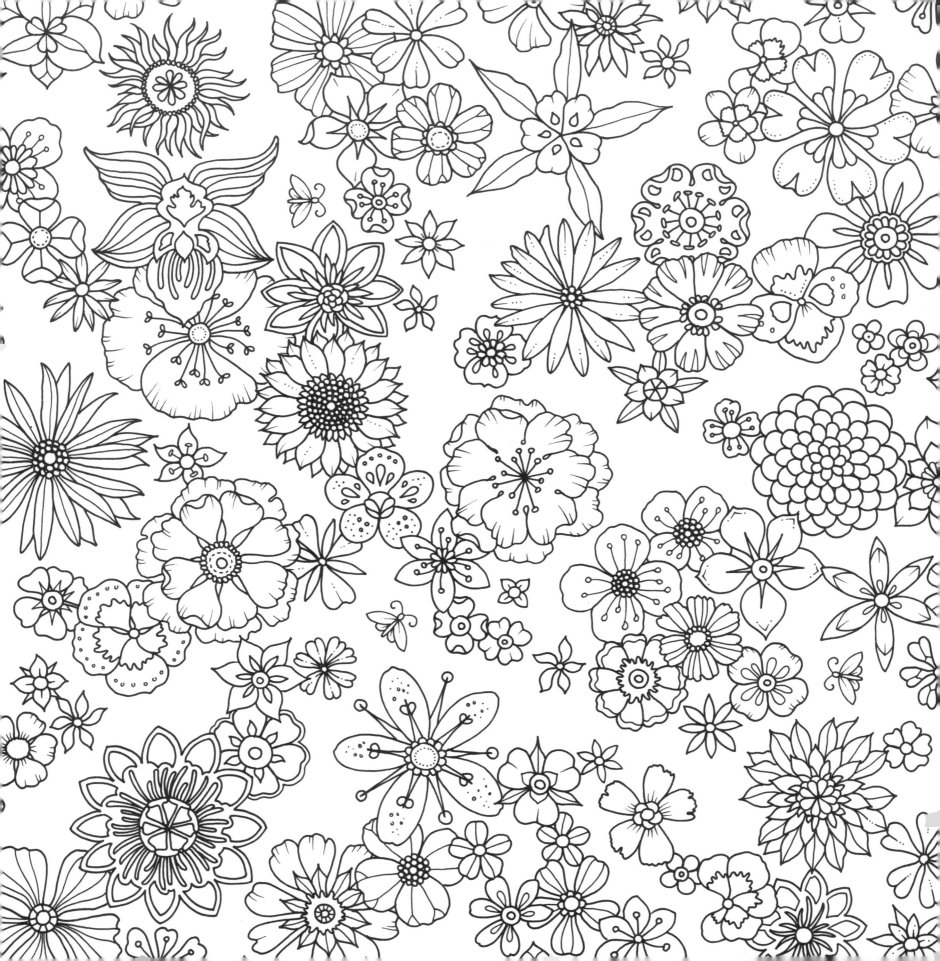

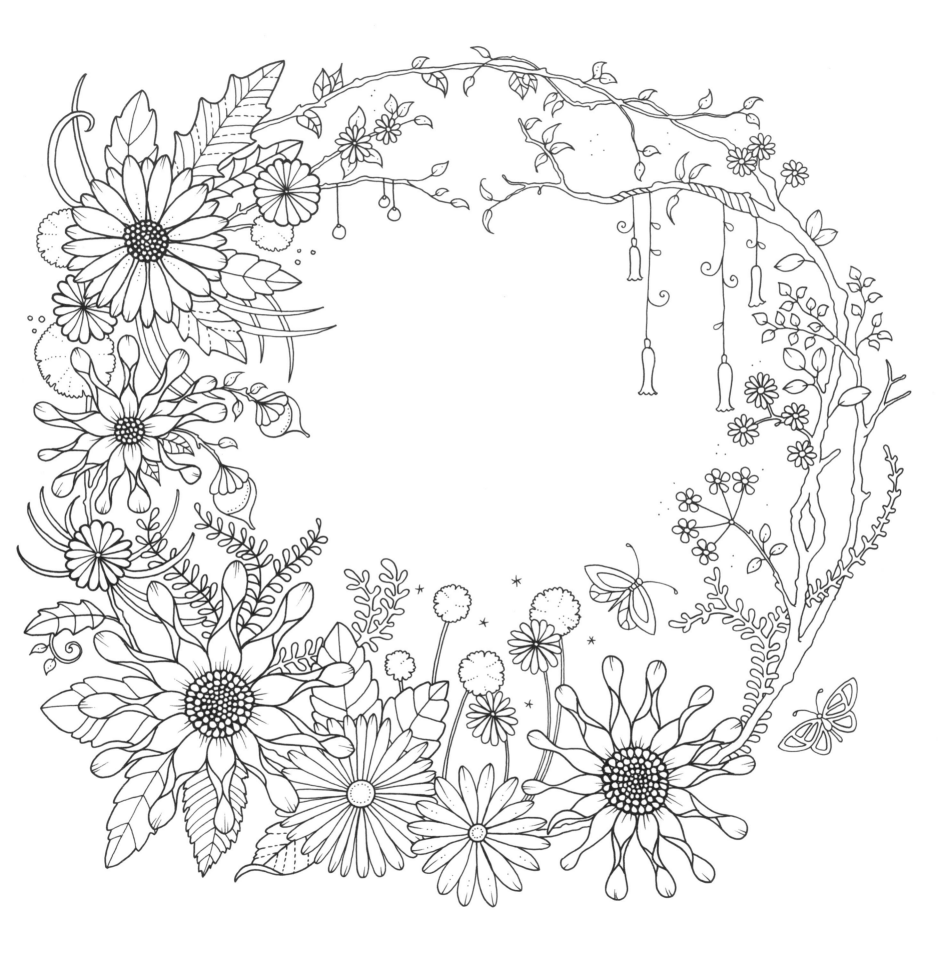

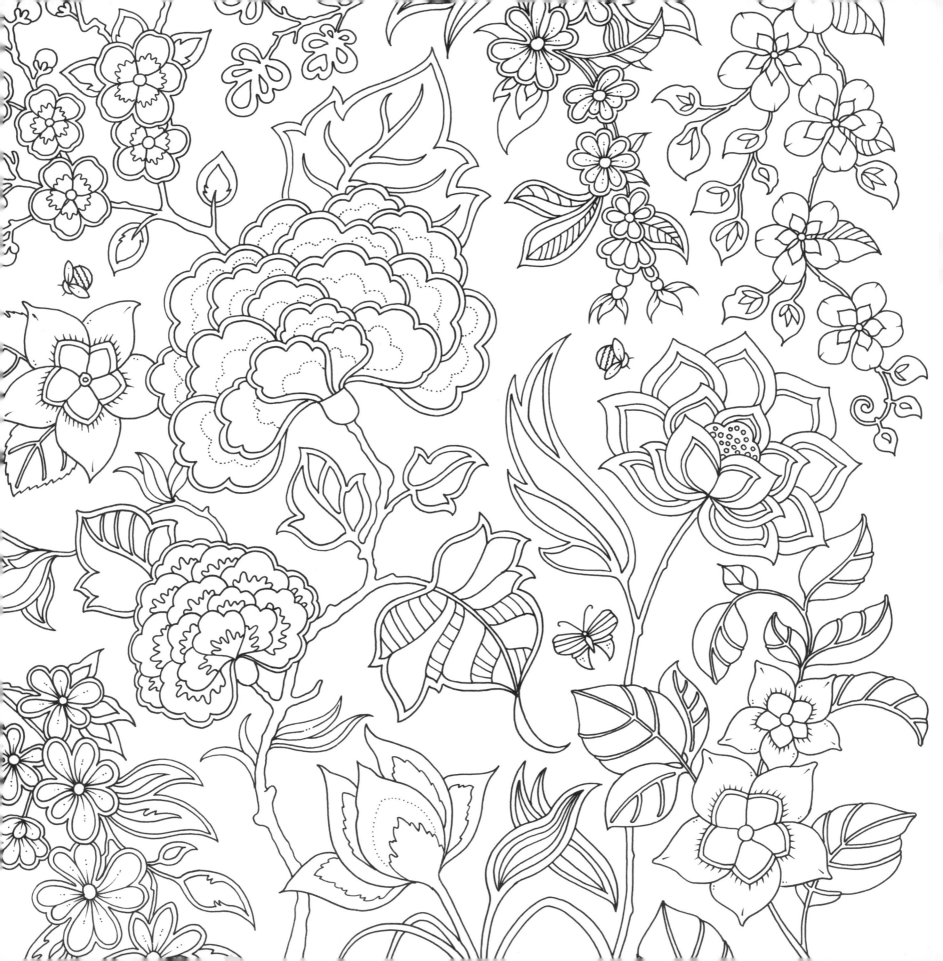

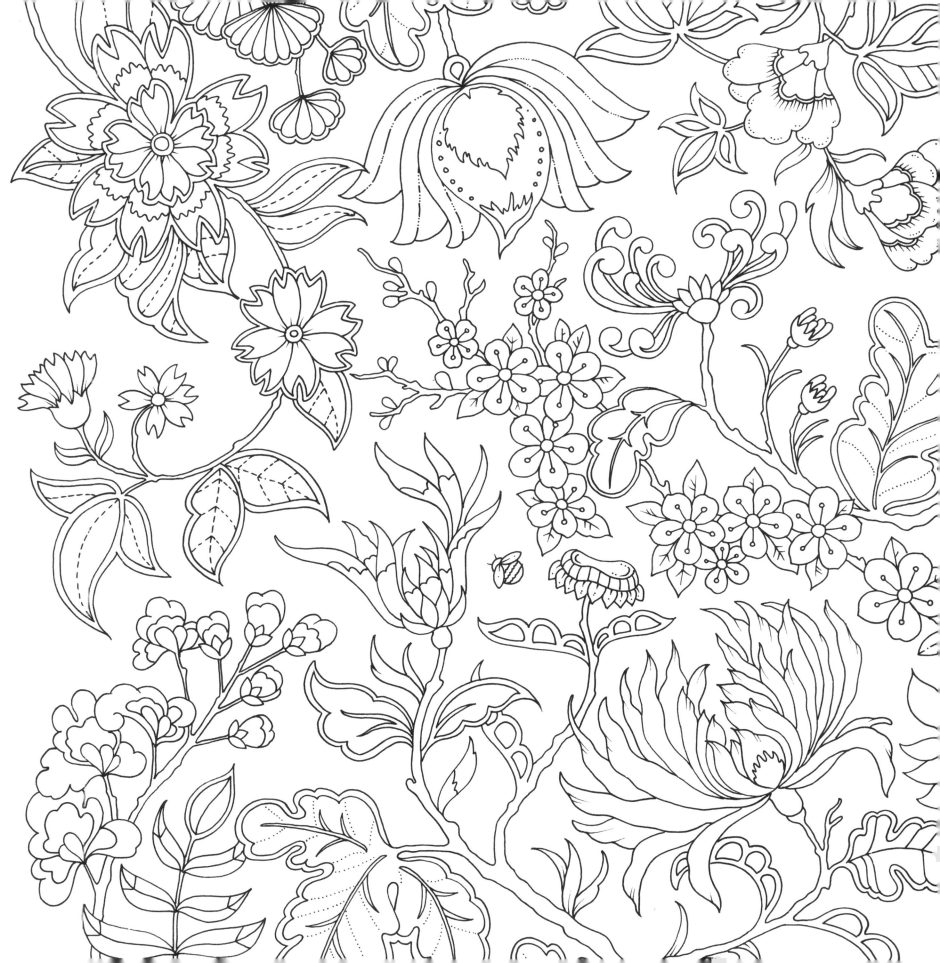

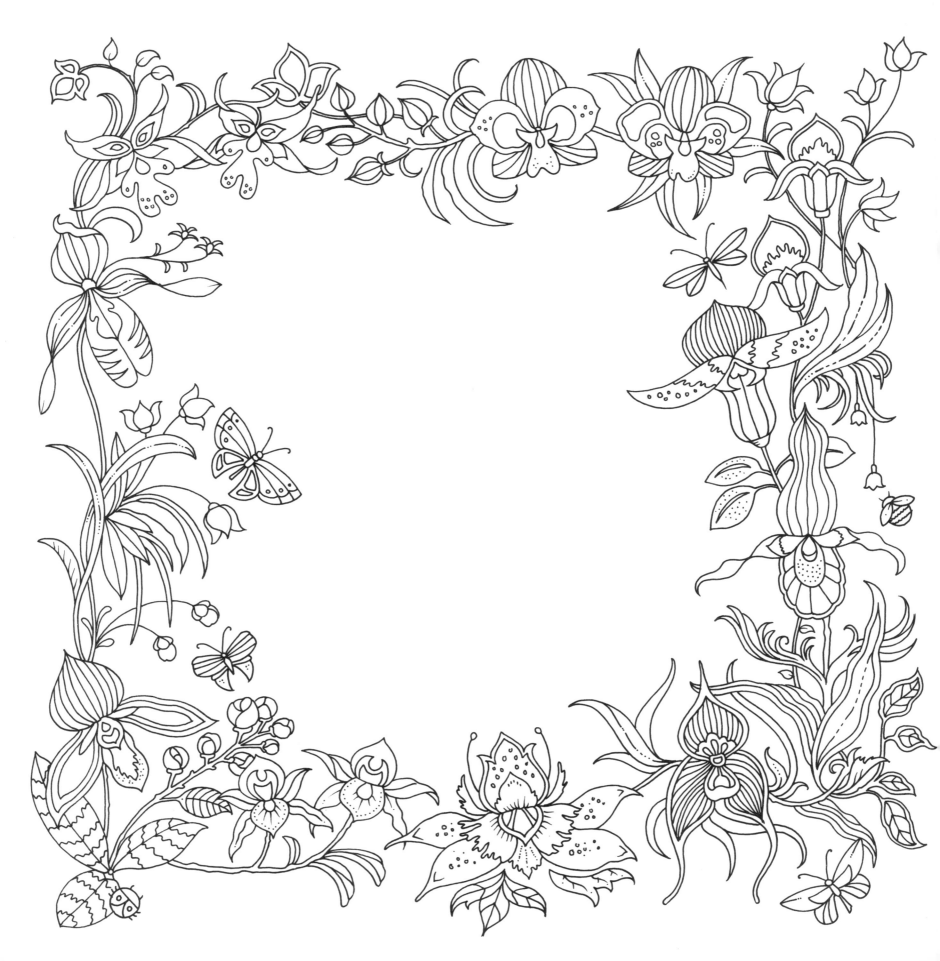

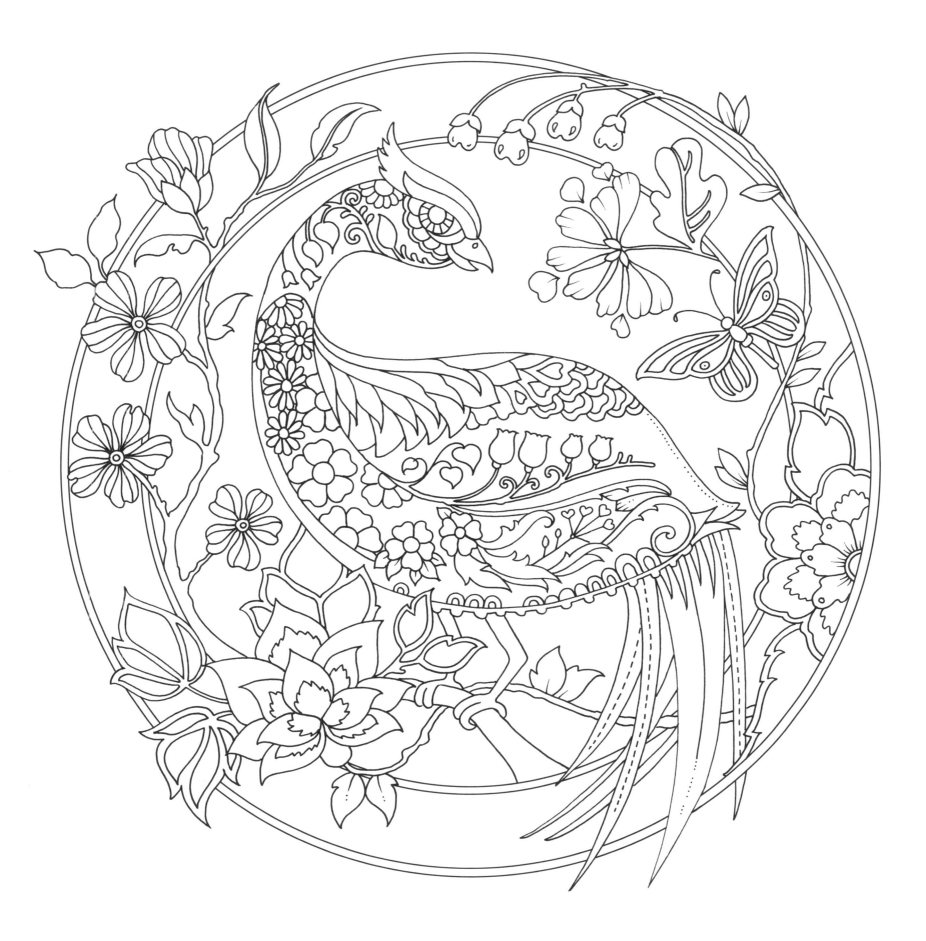

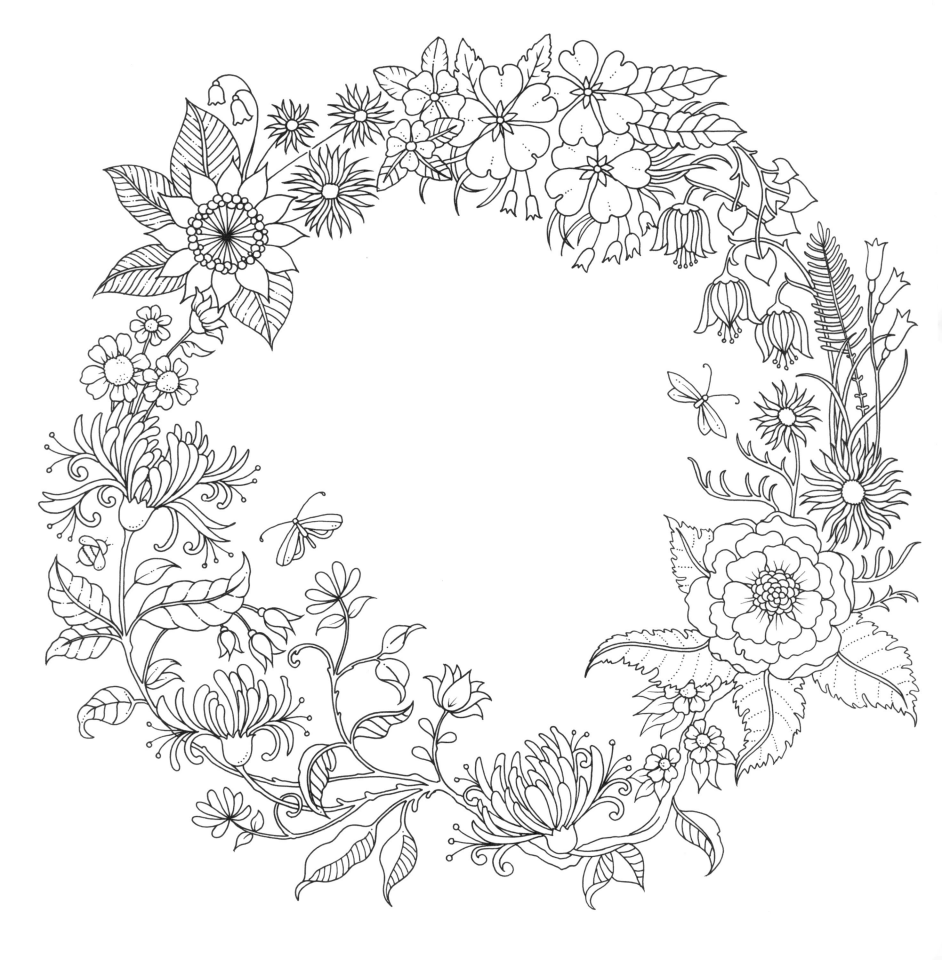

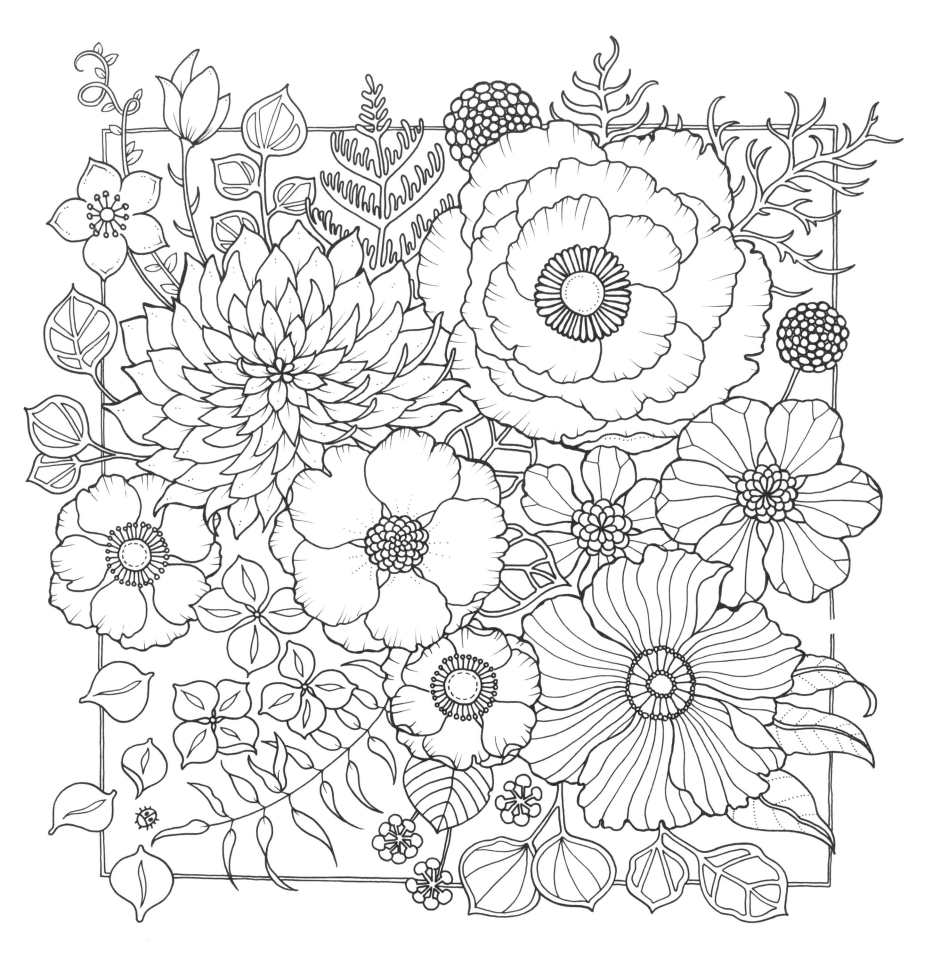

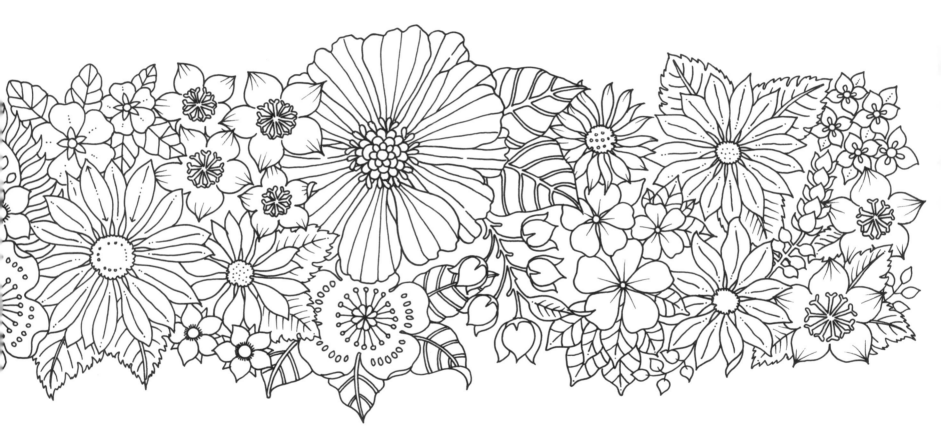

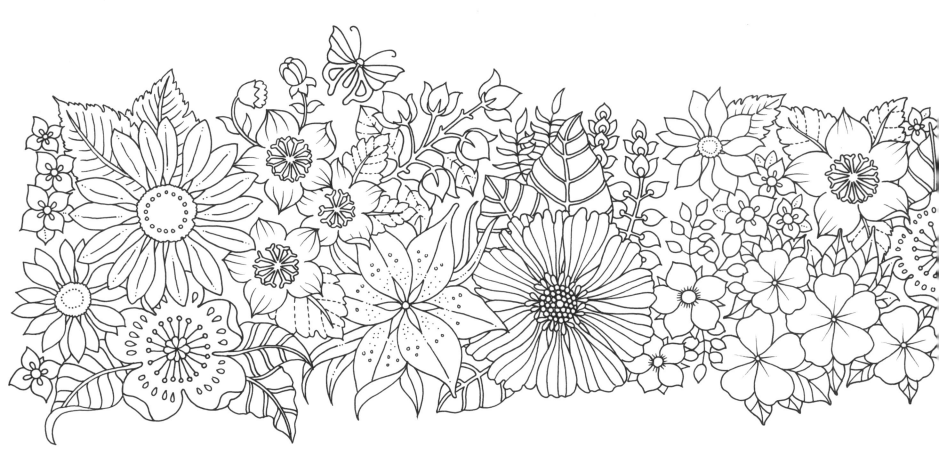

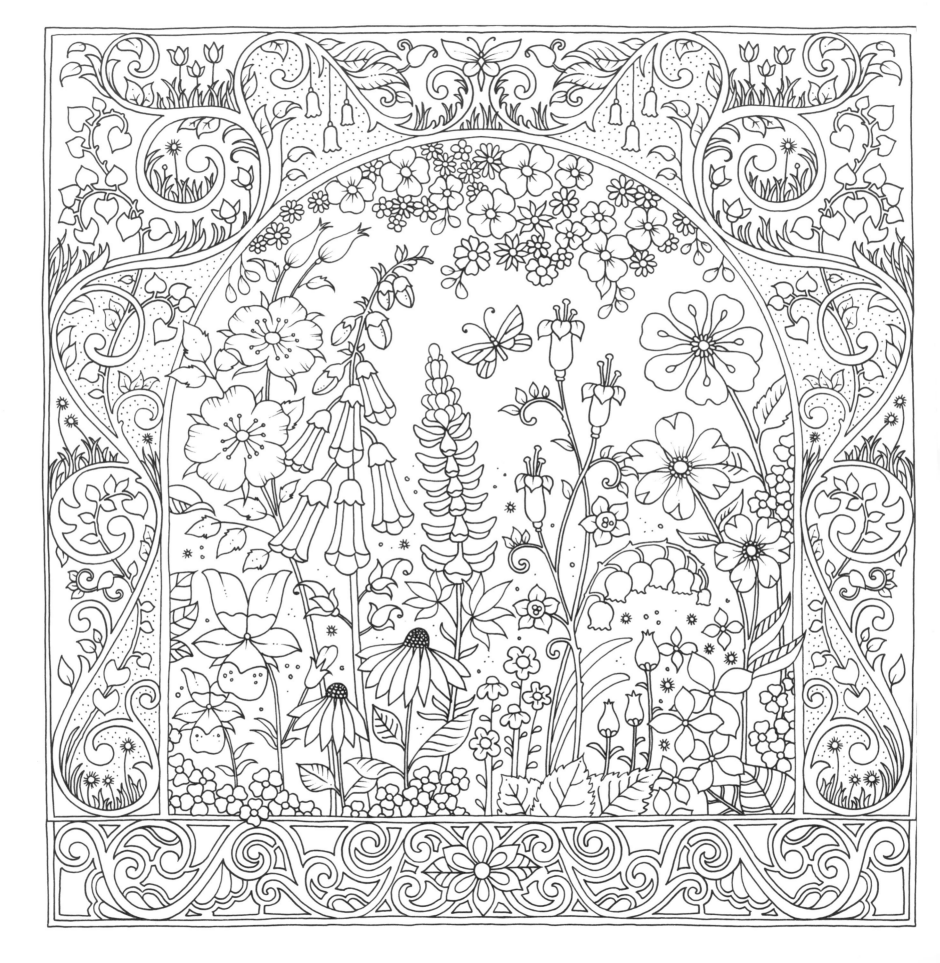

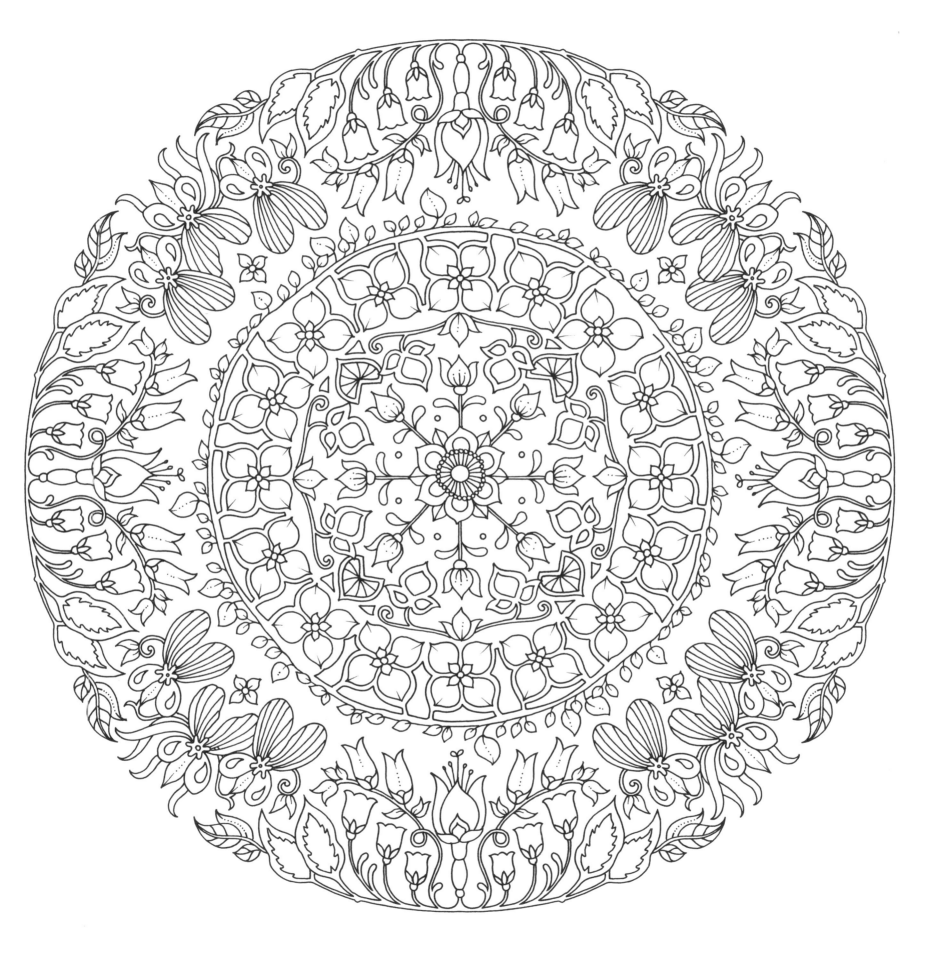

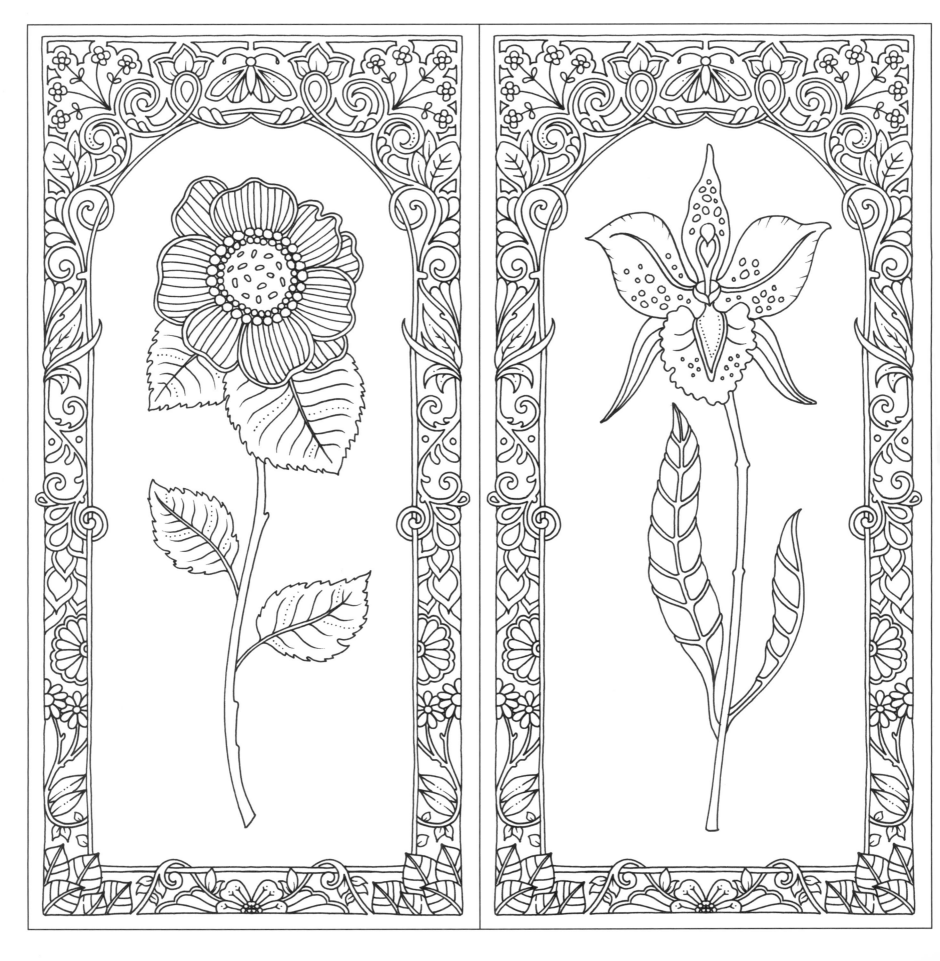

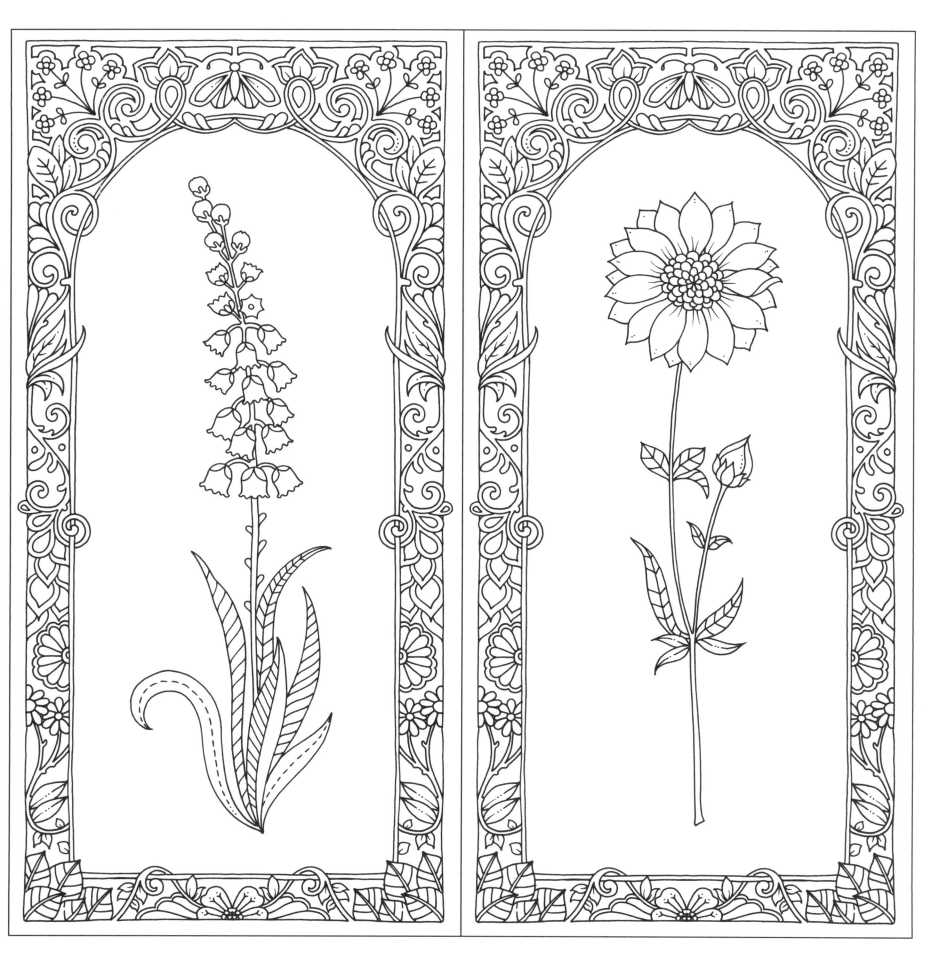

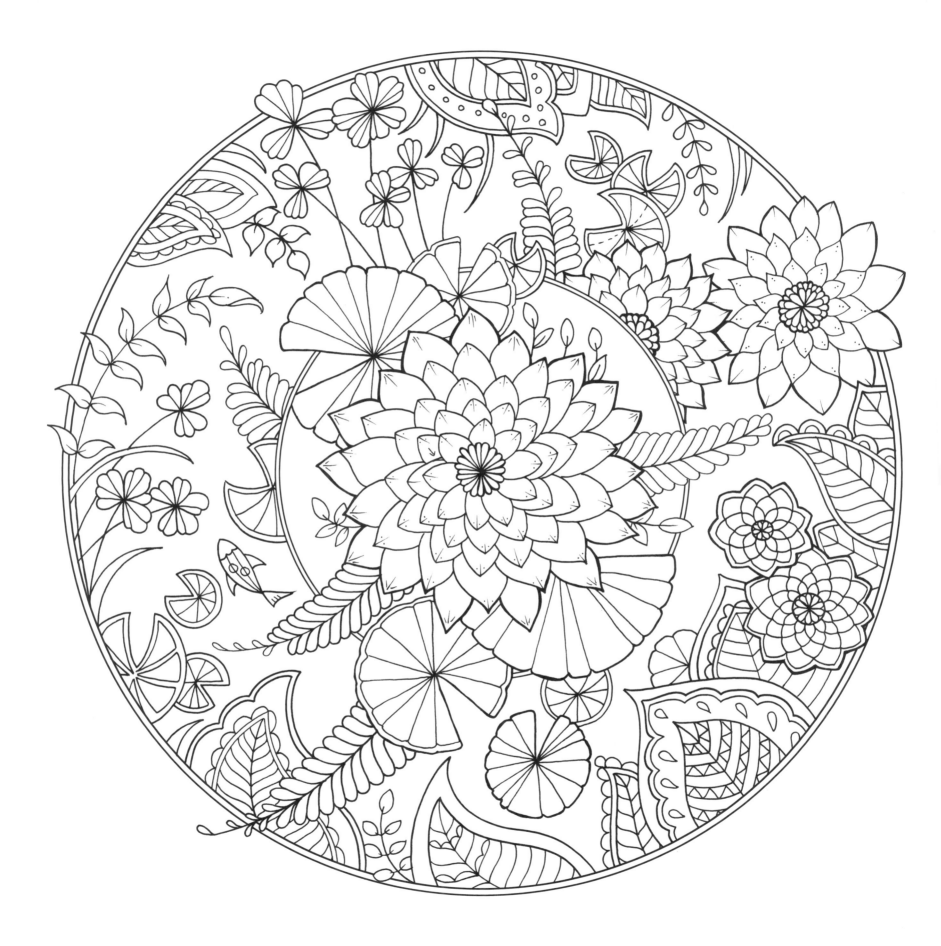

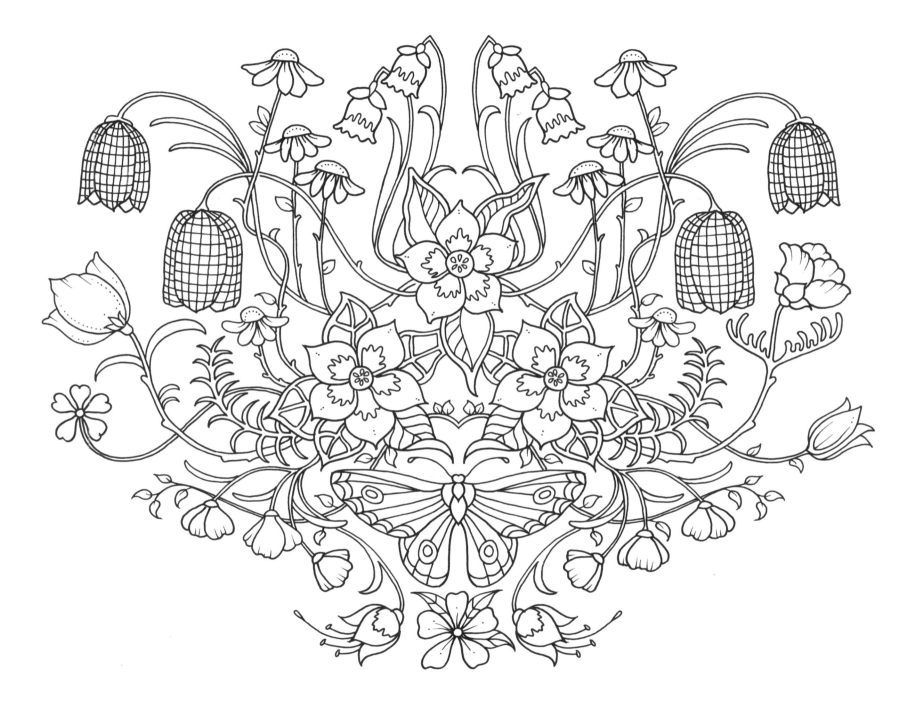

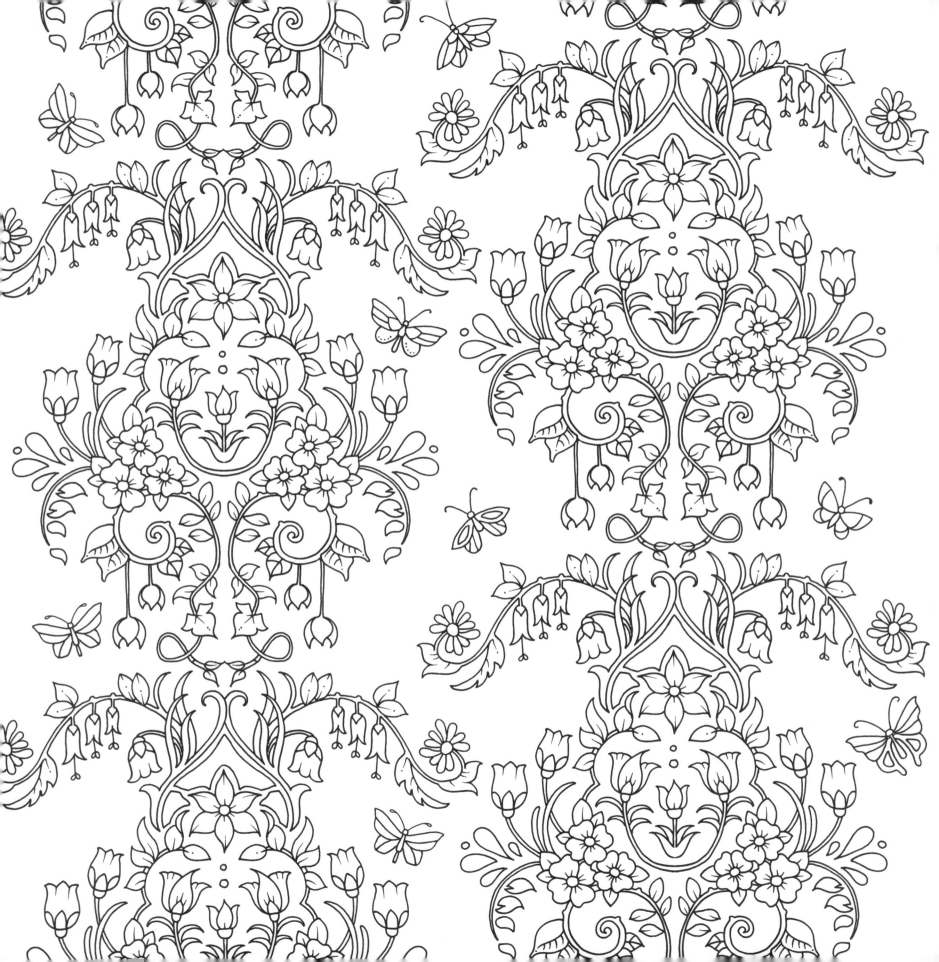

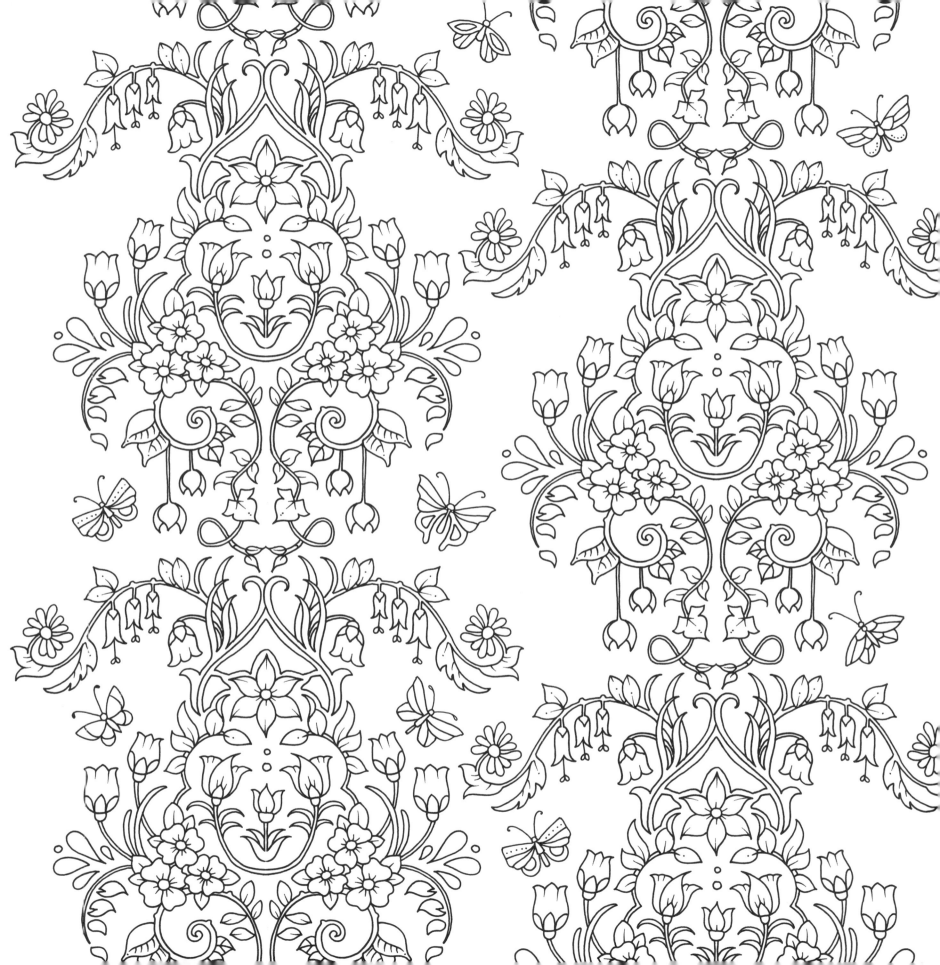

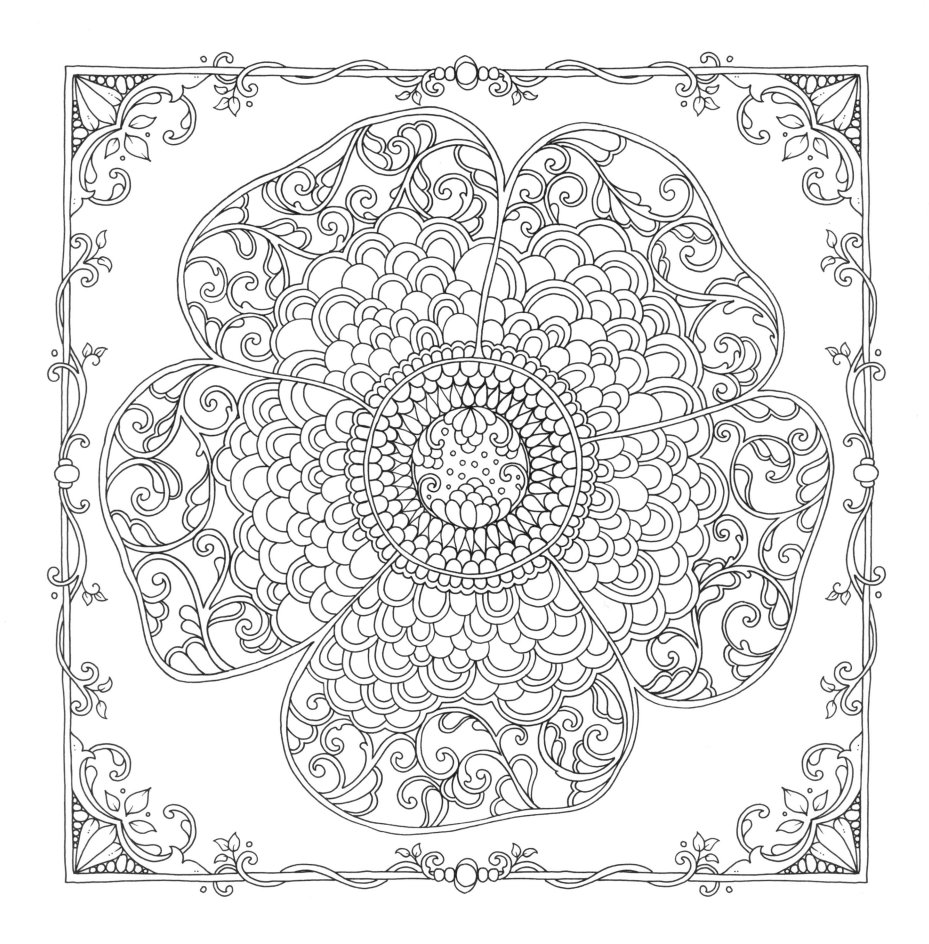

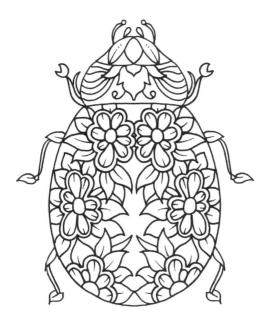
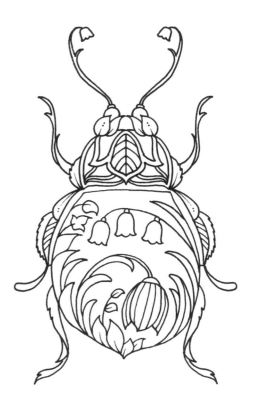
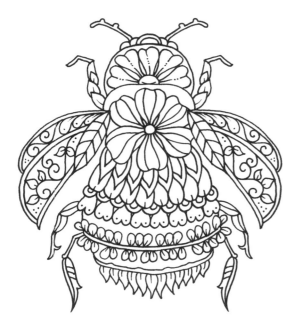
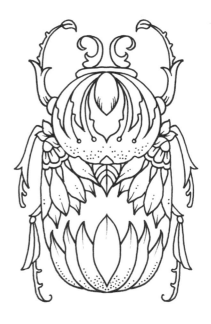

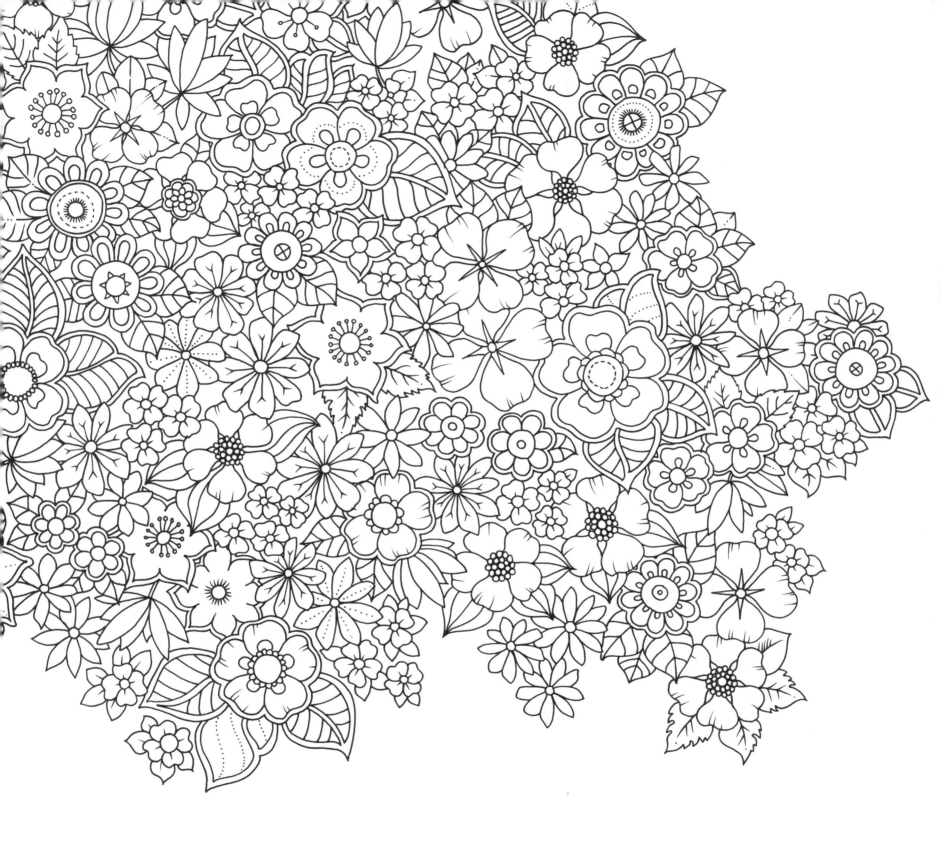

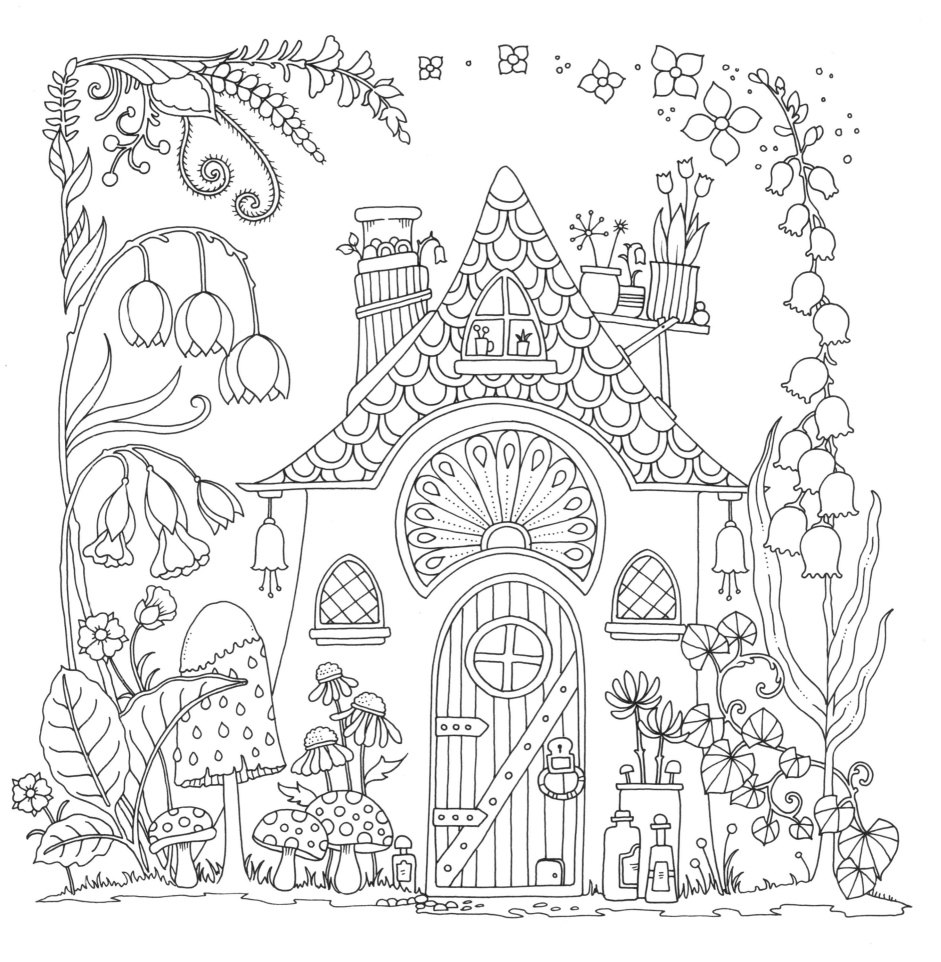

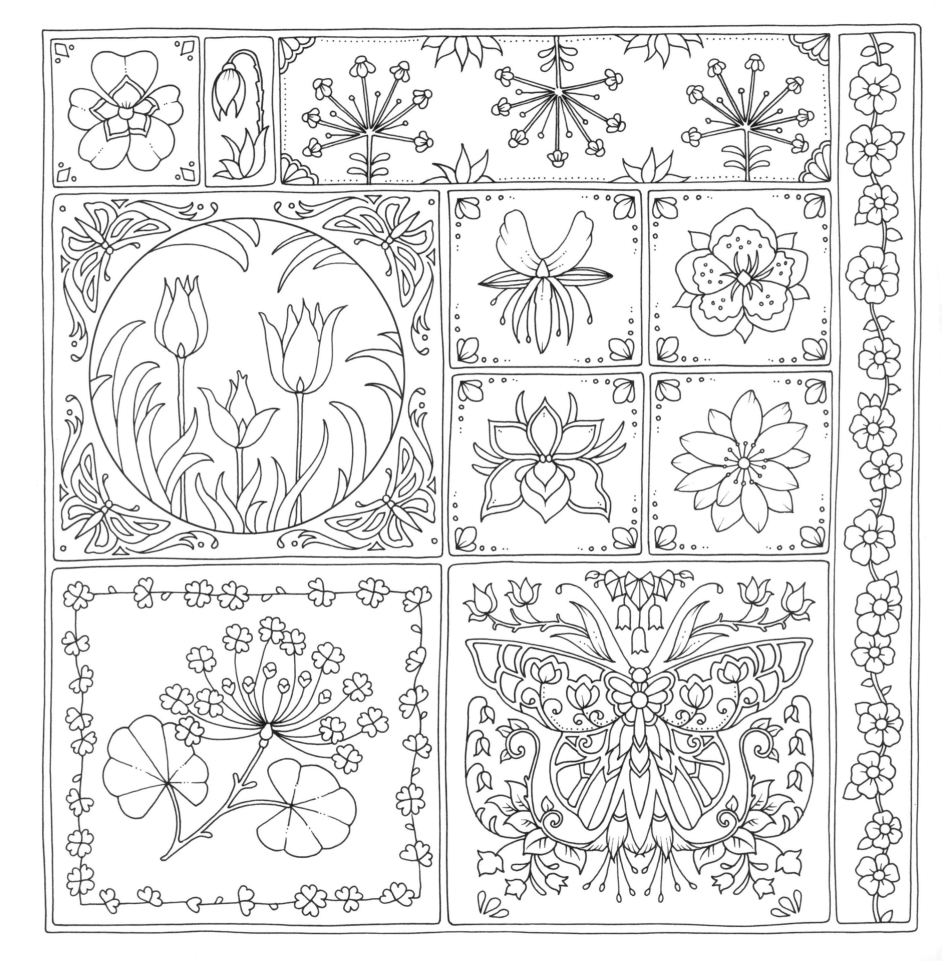

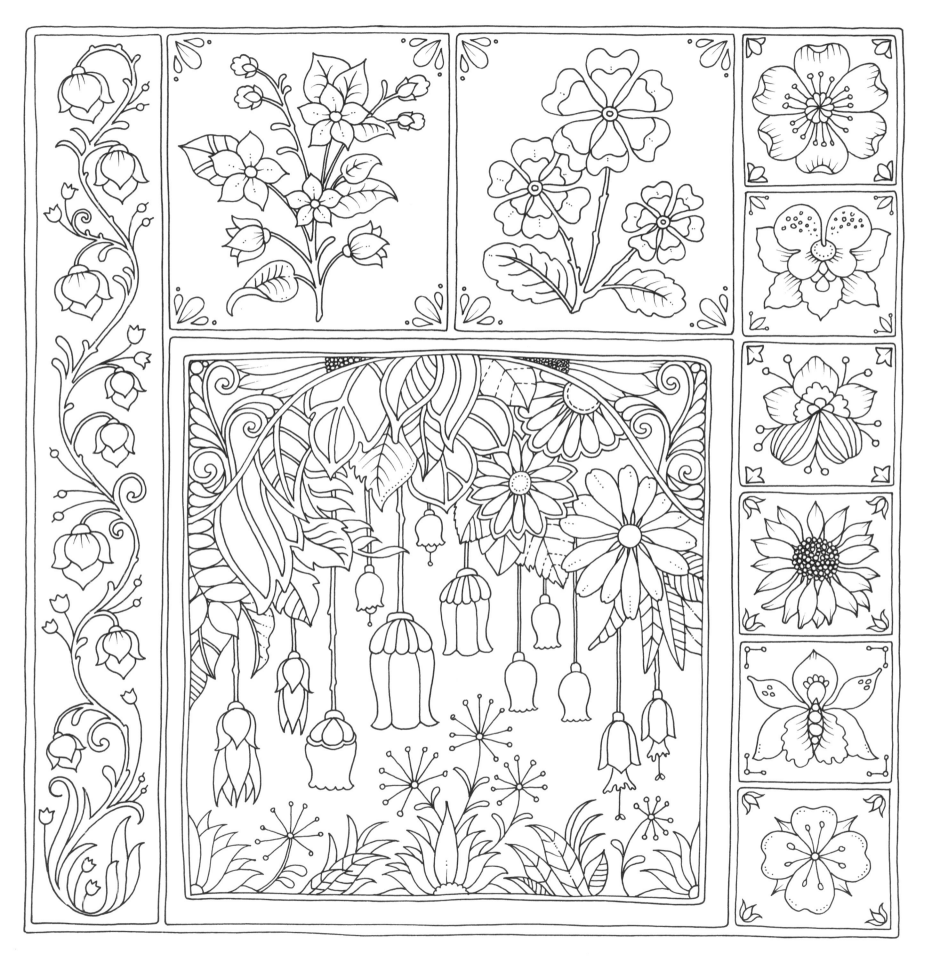

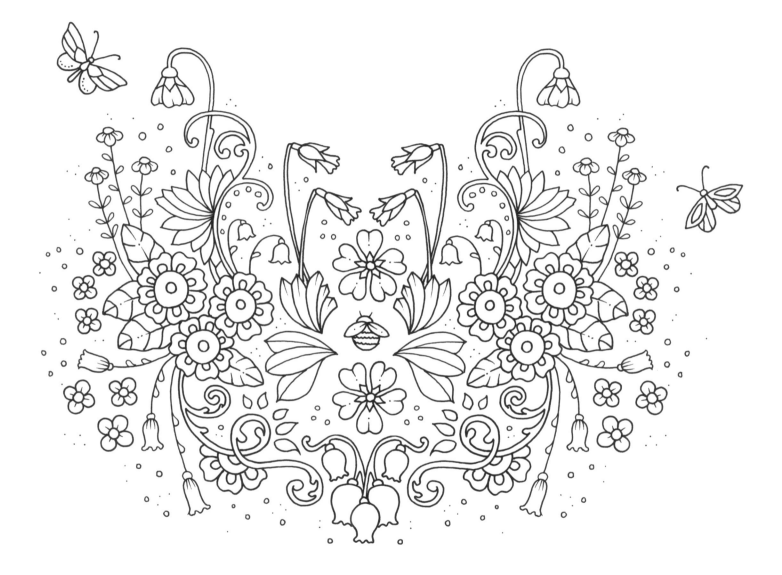

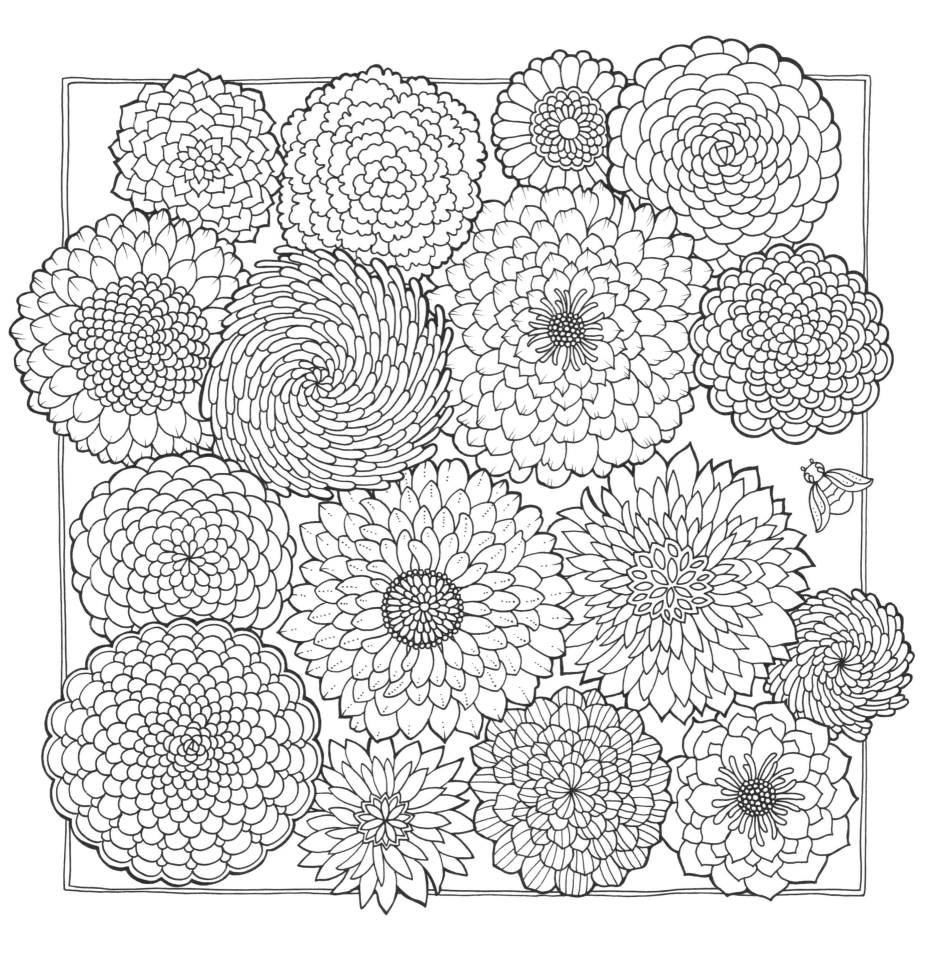

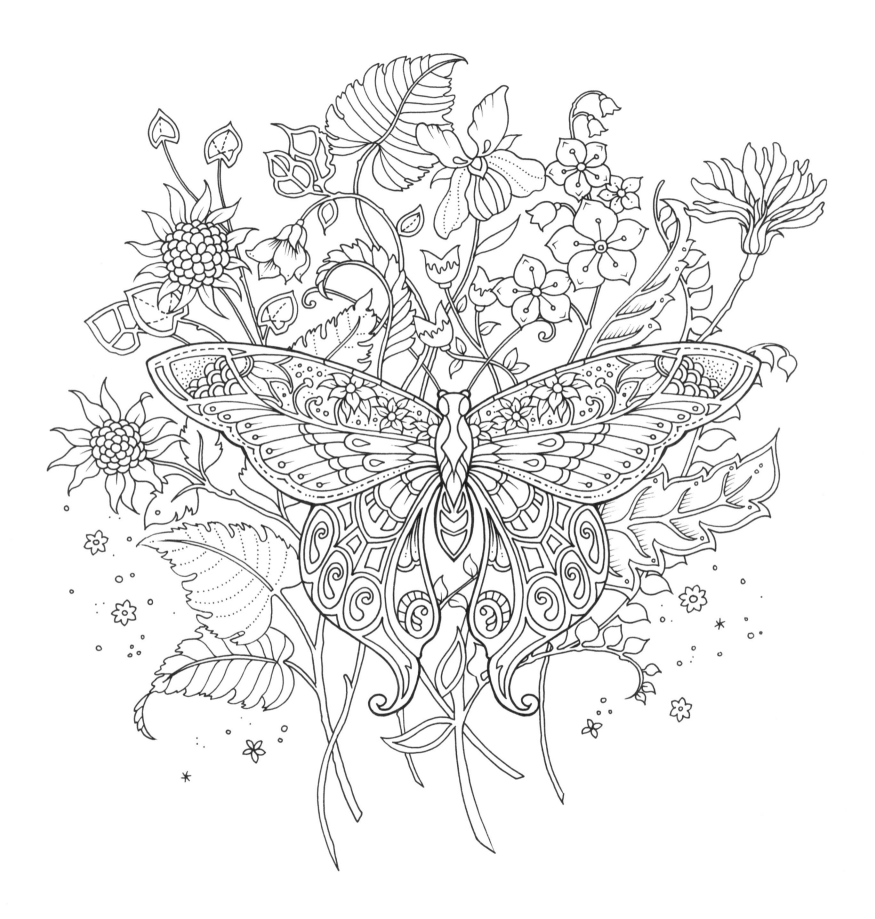

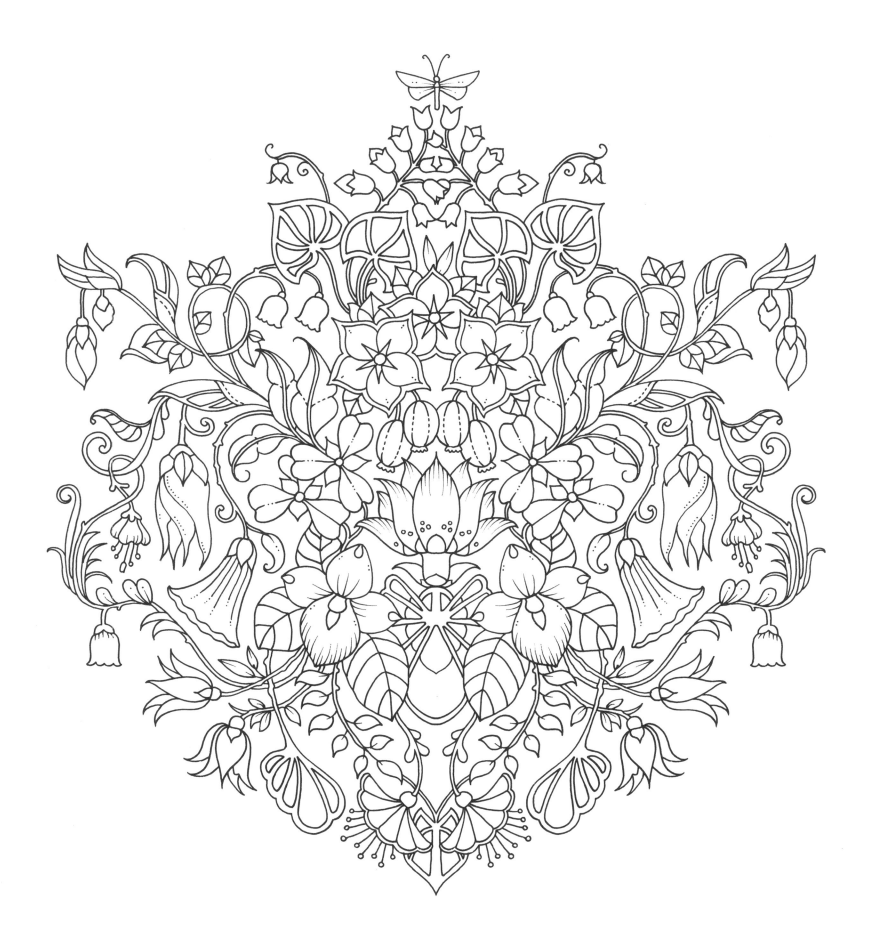

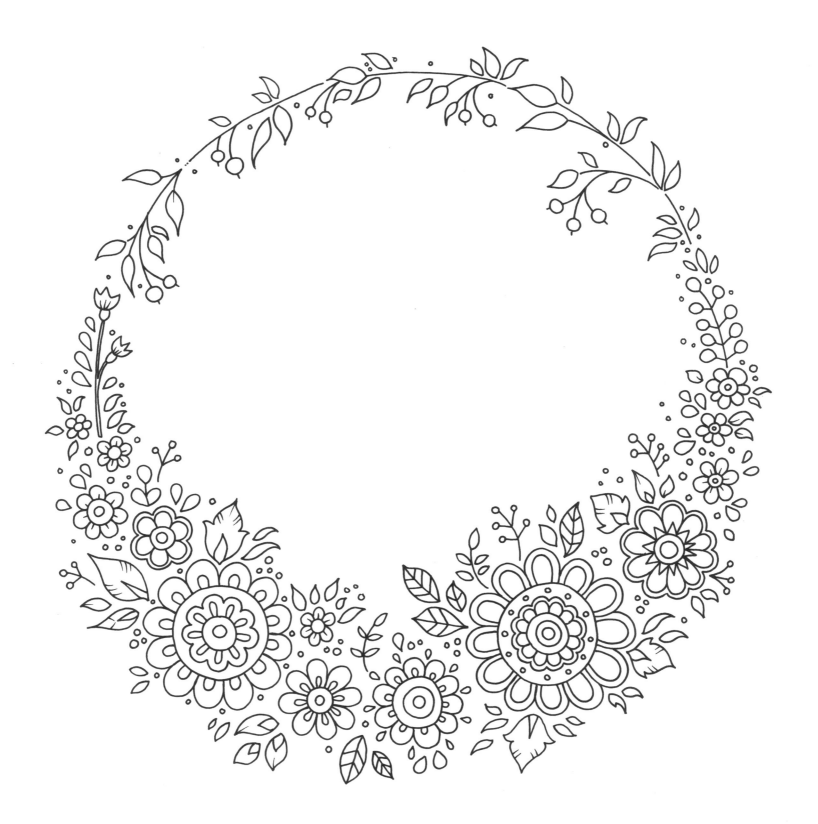

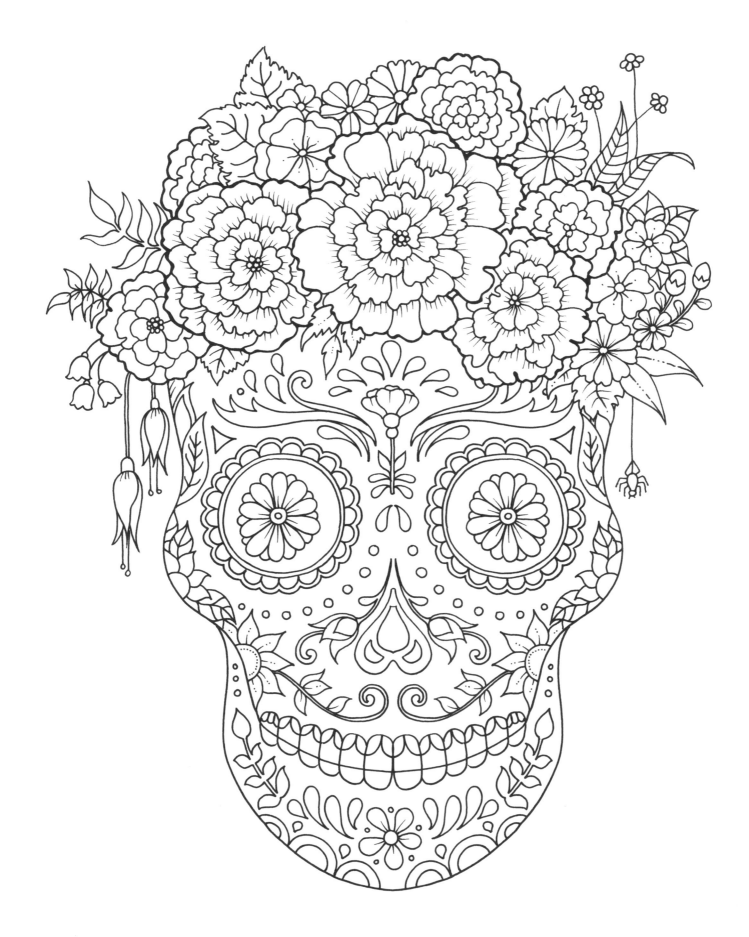

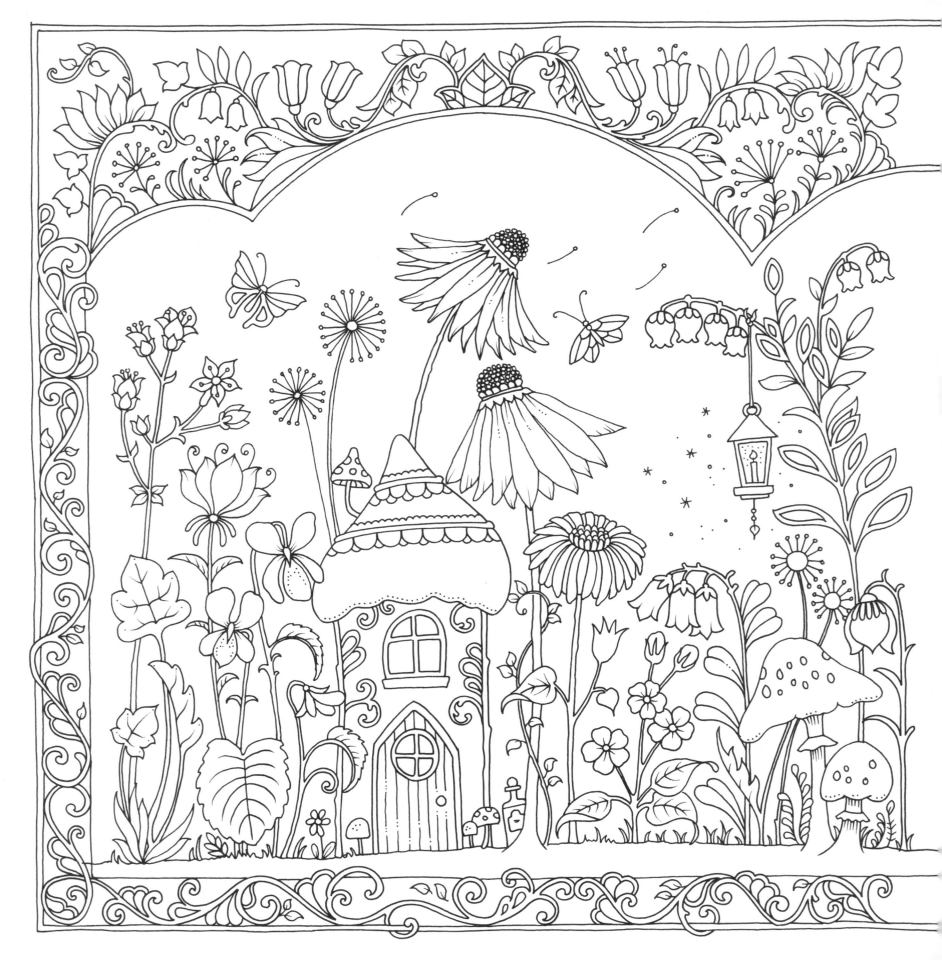

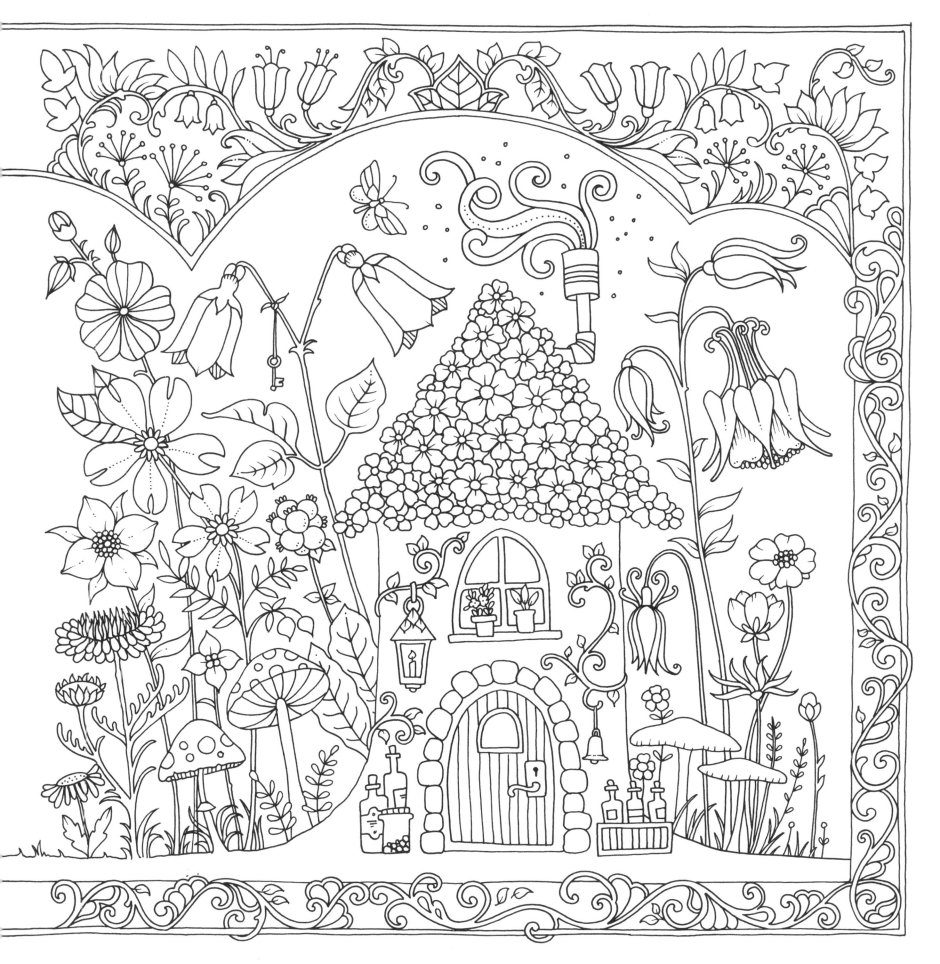

The End

Color Palette Test Page

Color Palette Test Page